MIXED MEDIA
COLOR
Studio

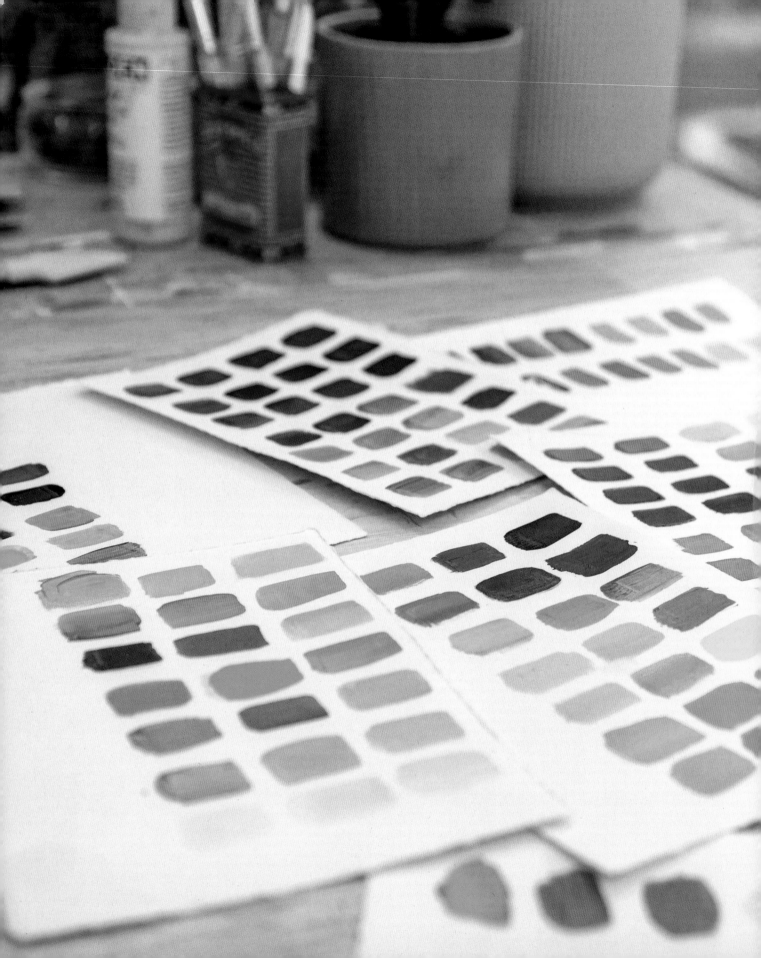

MIXED MEDIA
COLOR
Studio

Explore Modern Color Theory
to Create Unique Palettes and
Find Your Creative Voice

KELLEE WYNNE CONRAD

Brimming with creative inspiration, how-to projects, and useful information to enrich your everyday life, Quarto Knows is a favorite destination for those pursuing their interests and passions. Visit our site and dig deeper with our books into your area of interest: Quarto Creates, Quarto Cooks, Quarto Homes, Quarto Lives, Quarto Drives, Quarto Explores, Quarto Gifts, or Quarto Kids.

First Published in 2021 by Quarry Books, an imprint of The Quarto Group,
100 Cummings Center, Suite 265-D, Beverly, MA 01915, USA.
T (978) 282-9590 F (978) 283-2742 QuartoKnows.com

Quarry Books titles are also available at discount for retail, wholesale, promotional, and bulk purchase. For details, contact the Special Sales Manager by email at specialsales@quarto.com or by mail at The Quarto Group, Attn: Special Sales Manager, 100 Cummings Center, Suite 265-D, Beverly, MA 01915, USA.

10 9 8 7 6 5 4 3 2 1

ISBN: 978-1-63159-996-5

Digital edition published in 2021
eISBN: 978-1-63159-997-2

Library of Congress Cataloging-in-Publication Data

Conrad, Kellee, author.
Mixed media color studio : explore modern color theory to create unique palettes and find your creative voice / Kellee Conrad.
ISBN 9781631599965 (paperback)
1. Mixed media painting—Technique. 2. Color in art.
LCC ND1509 .C66 2021 | DDC 702.81—dc23

LCCN 2021003029

Design: Megan Jones Design
Cover Image: Becca Bastian Lee
Page Layout: Megan Jones Design
Photography: Becca Bastian Lee, Adobe Stock page 20, Guest artist images courtesy of the artists
Illustration: Kellee Wynne Conrad

Printed in China

This book is dedicated
to my Great Uncle Earl.
He told me I needed
to get busy making a
lot of art and so I did.
Your creative spirit
is always with me.

4 PALETTES AND PROJECTS 49

INTRODUCTION

How I Found Color

You probably picked up this book because you love color as much as I do. Color is compelling. And though it's not the only foundation of making art, it's the one we connect to first. When I began creating color palettes to share with my students, I instinctively knew what would make great combinations, but I didn't know why—nor did I know how to immediately achieve the same hues with paint.

I had a mission to discover everything I could about color. I have over three dozen books on color theory, color history, and color for home decor, but not one explained how to make the colors I saw and desired to create. I began experimenting with paint and expanded from there. Eventually, I landed on the formula I use today—mixing my own hues from the modern printmaker's colors: primary cyan, primary magenta, and primary yellow. I discovered I could mix just about any shades from these three colors, plus white, and found they were far superior to the traditional Old Masters palette. From this, my system was born.

The more you play, the more possibilities for creativity will open up to you. Be curious. Create for the experience first. You can't skip the practice, the process, and the patience to grow and become. When you are determined to live a creative life, the work must come before anything. Use this book to spark something in yourself, to study and explore everything about making art, and to discover what lights you up when you take the time to create for yourself.

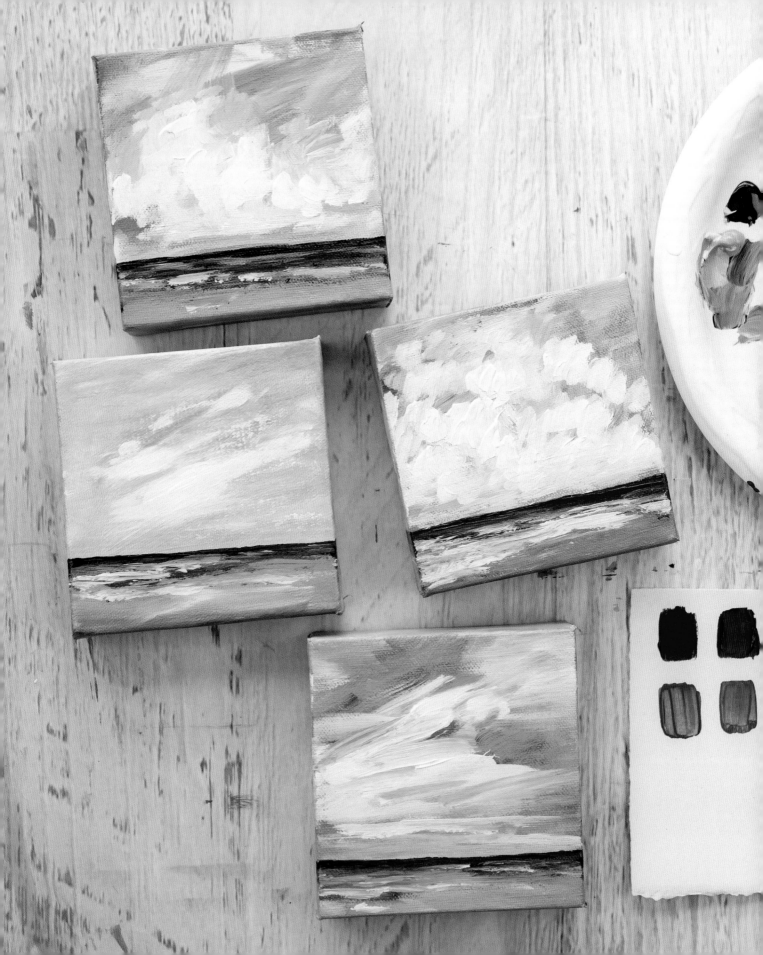

1

SUPPLIES

Oh, the thrill of walking into an art supply store and seeing all those pretty paint tubes lined up, calling to you to bring them home. But before you blow your budget, consider a few things: You don't have to have it all. A few tubes of paint, a surface to paint on, and a brush or two will give you a good start. I suggest using a variety of materials for the projects in this book, but I encourage you to be resourceful. Adapt with what you have on hand, substitute when possible, and be innovative with your supplies. If you are interested in learning about art supplies, we'll review the possibilities in this chapter.

MY FAVORITE SUPPLIES FOR MAKING A COLORFUL IMPACT

Selecting supplies is a personal process because it depends on the style of art you make and the specific techniques you prefer to use. I'm happy to tell you what I like, but the best advice I can give you is to get to work and discover what works best for you. When you play with materials, you'll see what feels natural to your process and to the type of art you want to make. With a bit of information, you can make informed choices.

Acrylic Paint

My favorite medium is acrylic paint. It's easy to use, fast-drying, very forgiving, and versatile. You can mix it with almost any other water-based medium and make magic with layer after layer of buildable paint.

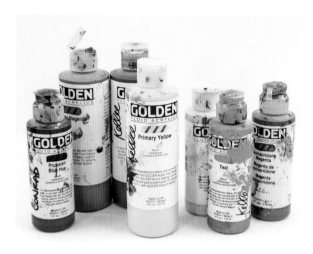

- The basic formula for acrylic paint is pigment plus an acrylic binder. Start with the best paint that fits your budget. Higher-quality paints contain more pigment and higher-quality binders, so colors are more saturated and cover more surface. These paints have better permanence or lightfastness over time, so your work won't fade. I can't say this enough: You will improve faster and be happier with the results by using better paint. I like Golden® Acrylic Paints for their quality and color selection.

- Student-grade paints generally offer less coverage because they have less pigment, and the colors tend to become darker as they dry. The binder is often weaker or has fillers that can leave your painting dry and chalky. But, sometimes cheaper paint is good for creating the first layers of large-scale works. I mix and match brands as needed, since all acrylic paints can be mixed.

- If you're on a budget, start with the three colors needed for modern color theory: primary cyan, primary yellow, and primary magenta, plus titanium white. You can always add more colors as you discover your signature palette, but having every color is never necessary when you know how to mix them.

- Paint viscosity refers to a paint's thickness, which affects how it flows. Heavy-body paint is thicker, offering painterly and often textured results. Fluid paint is more like heavy cream and can work as either a thin wash or for watercolor effects. Both can have the same pigment load, since only the binder is different.

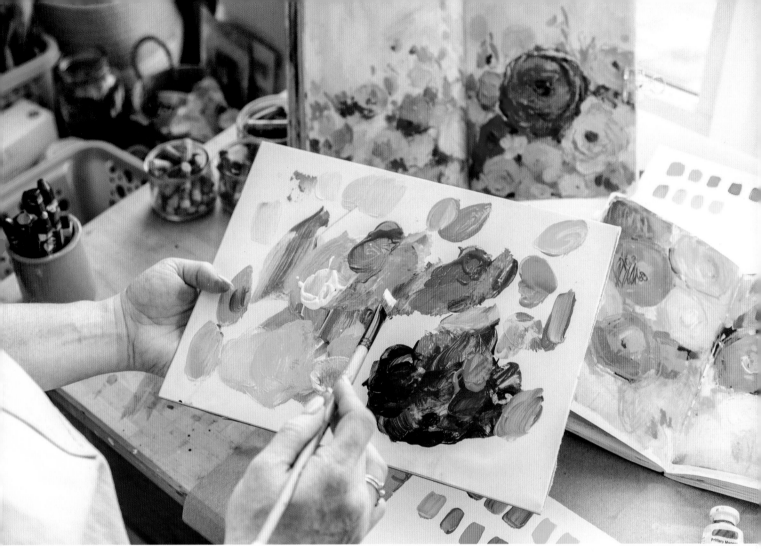

Quality Counts

If you're interested in selling your work, keep in mind that student-grade paints may not hold up over time.

Acrylic Mediums

Mediums can dramatically alter your paint by creating new and exciting textures and finishes for your work. Mediums control a paint's transparency, fluidity, texture, and surface sheen, while other additives control how long a paint stays wet and workable. Though I tend to like my paint pure from the tube, mediums can add extra punch to your work. Here are a few mediums to try; some are included in the projects in chapter 4:

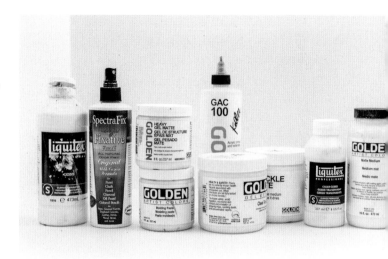

- **Gesso:** Traditionally used as a base for painting, gesso is made from a combination of pigment, chalk, and binder. Gesso prepares substrates, such as canvas or wood panels, for paint and other mediums. I use it as a substitute for white paint because it's fluid and opaque. Gesso also comes in a number of colors, as well as clear, which I use on unfinished wood so that the wood grain becomes part of my art.

- **Heavy-body matte gel medium:** Heavy-body gel medium is thicker than regular gel medium and may be blended with paint to create texture. It's my preferred adhesive for collage because it has a low moisture content and is less likely to wrinkle paper.

- **Fluid (or regular) matte medium:** This is a pourable medium that can be used for extending the dry time of paint and for decreasing its sheen. It can also be used as an adhesive for collage.

- **Texture mediums:** This category includes molding paste, crackle paste, glass bead gel, and tar gel—all mediums that will add texture to your artwork. Each has unique properties and can be blended with paint. The best way to become familiar with these mediums is to just play with them.

- **Fixative:** I prefer the brand SpectraFix. Unlike other potentially toxic fixatives, this one (made with casein, water, and alcohol) is low odor and can be used indoors. It seals and protects artwork and is especially useful for preventing graphite, pastel, and charcoal from smearing before adding an additional layer.

- **GAC 100:** This medium can be used for thinning or extending colors and for increasing the flexibility of paint. It is made from the same acrylic polymer base that Golden paint is made from. GAC stands for Golden Acrylic Colors, and the 100 is its series number.

Brushes

Finding the right brush is a matter of trial and error, but I have a few suggestions. Generally, a better brush that is well cared for will last longer.

- Acrylic paint can ruin a natural bristle, so synthetic brushes are recommended. These are generally more affordable, leave smoother brushstrokes, and hold and release more paint than natural bristles. I encourage artists to use a long-handle brush to keep their artwork loose and free. My favorite brushes are Princeton Catalyst Polytip brushes. They're a bit stiffer than most brushes on the market, which fits my painting style, and can hold up to vigorous wear.

- When choosing a brush, check to see if the ferrule is secure. The ferrule is the crimped metal section of the brush that attaches the bristles to the handle. Also, make sure the bristles are straight and even.

- Through experimentation and play, you can decide if you want your brushes to be stiff or soft, square or round, small or large. But don't limit yourself. A cheap brush for house paint can still work wonders. It's all a matter of preference and experience that will tell you which works best for you.

Mark-Making Tools

I can't get enough of lines, texture, and gestural marks. I'm willing to experiment with anything that will make a mark. I'm often asked why I scribble all over my surface before I paint, only to cover it up. This technique is such a beautiful release of emotion, and I'm also not starting with a blank page. I've begun my work with energy and motion that guide me into the next step of my process. This spirit continues while I'm working, as I love to run oil pastel or water-soluble graphite through my wet paint or add lots of marks at the very end of a piece to express my final touch. I highly recommend playing with all the supplies you have at your disposal to discover some great mark-making tools. These are a few of my favorites:

- Water-soluble graphite is one of the most versatile ways to add instant drama to mixed media, and it is my first choice when I want to shake things up. I like chunky pencils or sticks, such as Lyra or ArtGraf®, and I add marks where my intuition leads me—sometimes to start a painting and other times when I want to let loose on a painting that is turning in the wrong direction.

- Oil pastels are like crayons for adults. They're made with a high pigment load, oil binder, and wax and are perfect for adding a finishing touch to your art. They are great for making a strong mark through wet paint or for adding final details. One caveat: Don't add acrylic paint over the pastels. The acrylic paint won't adhere properly because it's oil based.

- You can also incorporate colored pencils, acrylic paint markers, charcoal, fine-line black markers, chalk pastels, and a simple number 2 pencil. I like using chunky Stabilo® Woody 3 in 1s, which are colored pencils, wax crayons, and watercolors all in one and are very fun to use.

Collage Elements

I love paper and found objects, including clever packaging, clothing tags, and doodled notes. I save them all. Collage resources are endless if you keep your eyes open. If collage layers speak to your design sensibility, add them to any work of art. Using found treasures is a great way to preserve pieces of your life in your artwork and make it more uniquely you. Here are a few sources for ephemera to explore:

- Daily consumption items: magazines, flyers, packaging, tags, junk mail, gift wrap, note cards, receipts, and event tickets

- Purchased supplies: textured handmade paper, origami papers, scrapbook paper, stickers, tape, wrapping paper

- Vintage finds: maps, postcards, book pages, letters, ledgers, advertisements, labels, wallpaper, dress patterns, diaries, sheet music

- Handmade: hand-printed textures, stamps, drawings, painted patterns, gel prints, leftover scraps from art making

Tip

More Collage Fodder
Here are more ideas for making collage papers: Make marks with paint pens or pencils and randomly stamp or paint on magazine pages, or create repeat patterns. Use your imagination and create a pile of your own art that you can use in your own art. How original!

GEL PRINTING YOUR OWN COLLAGE PAPERS

As much as I love collecting found treasures to use in my work, there is nothing I relish more than using my own art papers. Make art out of your own art? Yes! While this book shows you how to use color in mixed media projects, I want to share the pleasures of creating your own mixed media materials. I'll get you started with gel printing, but be warned—once you start, you won't want to stop.

A gel printing plate is a hypoallergenic polymer material made with mineral oil that's meant to replicate a homemade gelatin printing plate. I believe it's better to buy a premade plate instead of making your own because it can last for years.

I like printing on cheap copy paper because it prints well and is thin enough to use easily in collage. I also use deli paper (yes, the same stuff they use to wrap sandwiches). I also print on found papers, such as sheet music and old book pages. To print, you'll need paint (I prefer fluid acrylic, but heavy-body paint works as well), a brayer, and mark-making items that won't damage the plate: stencils, stamps, silicone hot pads, placemats, bubble wrap, cardboard, packing materials, leaves, flowers, feathers, string, brushes, etc.

1 | Start with a small amount of paint on the plate. If you use too much paint, you won't get good prints. A penny-sized amount will do. Use a brayer to roll out a thin layer of paint across the plate (use two colors if you'd like). Roll any excess paint on scrap paper.

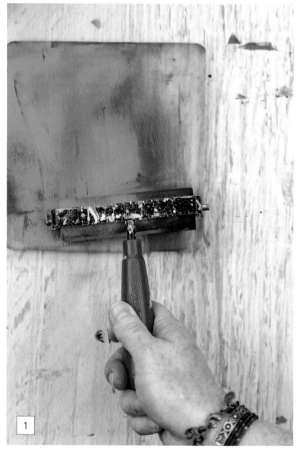

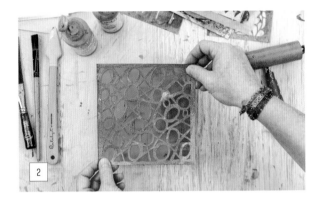

2 | Place a stencil on the plate. You can also press soft-textured items, such as bubble wrap or corrugated cardboard, into the wet paint to create patterns.

3 | Press a sheet of paper onto the plate and rub around the cutouts in the stencil. Gently pull the paper off the gel plate.

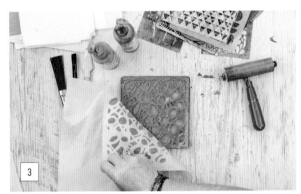

4 | Remove the stencil and wait one or two minutes for the paint to dry on the plate. Add another thin layer of lighter or darker paint with the brayer. Place another element on the plate, such as another stencil, a stamp, or an item that creates texture or a pattern. I added string.

5 | Press a clean sheet of paper onto the plate and pull a print. Experiment and repeat for long, blissful hours of relaxation.

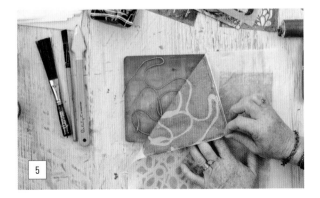

Substrates

PAPER: Paper is available in smooth or rough texture, heavyweight or lightweight, and is made for a variety of uses, such as mixed media or watercolor. While it's easy to get lost in the choices, I use one paper for all my mixed media projects: Stonehenge® printmaking paper by Legion. This paper is smooth and lightweight but still sturdy enough to accommodate all my layers of paint and collage. Stonehenge is available in a range of colors, and my favorites are white, fawn, and kraft. I use large sheets for bigger artwork, or I tear it into smaller sizes, which gives me beautiful deckled edges. I often float my work in a frame to reveal all the details up to the very edge of the painting.

Creating Hand-Deckled Paper

Measure and mark the size of paper you want with a pencil. I prefer to tear a large sheet of paper in half and then in half again.

On a flat surface, fold the paper where you intend to tear it. Fold it again in the opposite direction. Use a ruler or a bone folder to press the crease each time.

Pull the sides of the paper away from each other, rather than pulling one side from the top. Go slowly. If the tear goes in the wrong direction, turn the sheet over and begin tearing from the opposite side.

CANVAS: I like using professional-grade stretched canvas with 1½-inch (3.5 cm) deep sides so I don't have to frame my artwork. If you paint the sides of the canvas, your artwork will look great hanging on a wall. Use student-grade canvases with caution because the stretcher bars may be weak and the canvas may warp or rip over time, especially if your work is layered. I always add a coat of gesso to my canvas before I begin painting to ensure the artwork will last—just in case someone wants to keep my work for a hundred years or more!

BOARDS: Cradled wood boards are one of my favorite surfaces to work on because they're sturdy, not flexible, and can hold layer after layer of mixed media. I always tape the edges of the board before painting to preserve the wood for hanging. I use unfinished wood boards and prepare the surface with an even coat of clear gesso or matte medium, which allows the wood grain to show through. I also use white gesso as a base, spreading it unevenly across the surface with a brayer. This allows the wood to show through in spots, especially the edges.

Here's how to prepare a cradled wood board:

1 | Tape the edges of the board with painter's tape or clear packing tape to preserve the natural wood sides.

2 | To allow the wood grain to show through as you paint, prepare the surface with clear gesso or fluid matte medium. This also seals the surface.

 If you wish to use white gesso as a base, squeeze some directly onto the board and use a brayer to evenly cover the surface. Allow the gesso to dry completely before beginning your painting.

ART JOURNALS: Do not discount the power of an art journal. Working in an art journal lets you try ideas without worrying about producing a finished product, and you can also keep a history of your ideas and progress. Some artists don't see the point of art journaling because the art in it can't be sold. That ignores the joy of creating just for the process, and it skips a vital step: practice.

I highly encourage you to invest in an art journal so you can use it for the warm-up lessons in this book and refer back to your previous work. Don't skip the warm-ups because this is how, over time, you will learn to master color. Any type of art journal will do, but these are my favorites:

- **Strathmore® Mixed Media:** This spiral-bound book lies flat or can be folded back. I often use this style of journal for color collecting.

- **Bound journals with heavy art paper:** My preference is the Stillman & Birn Epsilon Series, which has smooth bright white paper. The paper isn't as heavy as watercolor paper, but it's strong enough to hold all my layers of paint.

- **Discarded books:** I love turning old catalogs, storybooks, or cookbooks into art journals by adding a very light layer of gesso to each page before I begin painting. These art journals are not precious, and original printed book pages lend new ideas and a certain type of freedom to explore without risk.

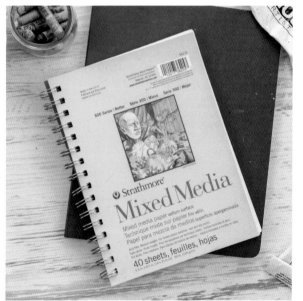

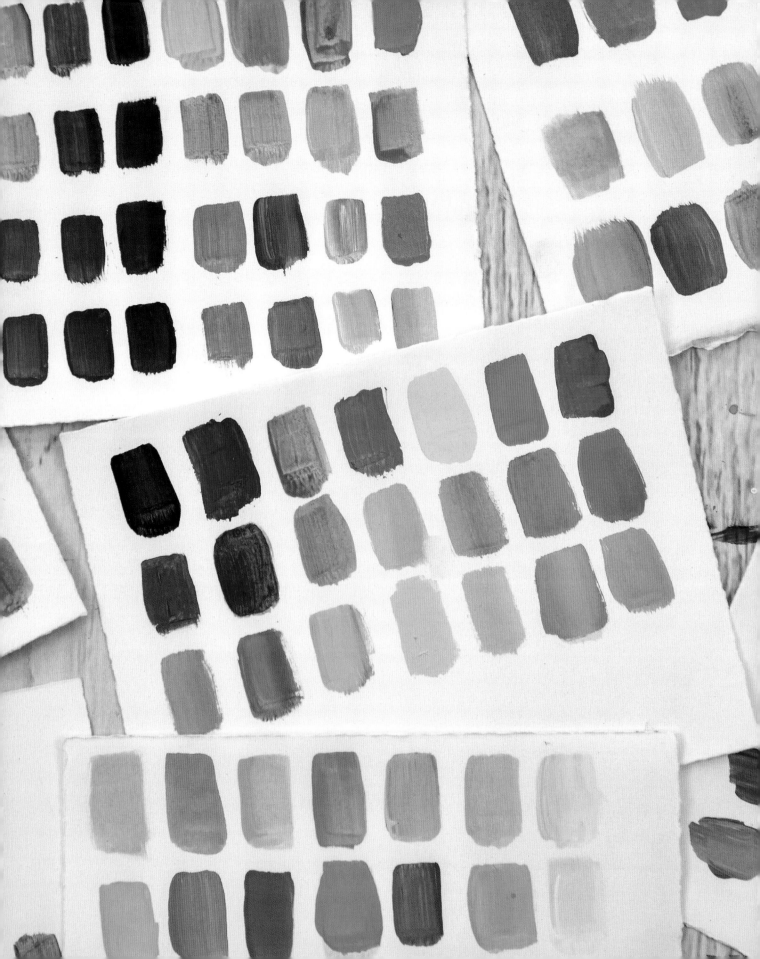

DISCOVERING YOUR SIGNATURE COLOR PALETTE

Color is part of my identity as an artist. I'll bet that if you looked at your work, you would see a color pattern as well. When you paint, do you have a go-to palette or know how to identify one that is materializing as your own signature color combination? A golden thread runs through your work and your life, and it's the key to your own signature color palette. The best way to discover your signature color palette is to see the world with wonder. Figure out what lights your soul on fire and then embrace your natural path toward creative expression. Soon you will see color combinations everywhere you go that you simply can't resist.

A GUIDE TO CREATING YOUR PERSONAL COLOR PALETTE

My number one tip for both beginners and experts in finding your voice, knowing your style, and choosing your color palette is that you have to make a lot of art to know how to make your art. This is universally true, and there is no magic recipe. You have to make a lot of artwork. You even have to make bad artwork—it's the best teacher. The more you make, the more you will begin to understand what you like and don't like, what works for you and what doesn't, what excites your soul and what bores you. These discoveries will lead you to where you want to go. And as soon as you think you know, you must do it again because we are ever-changing and growing.

The willingness to grow and stay open spills into creating a personal style, and eventually your signature color palette will emerge. As you explore your creative process, your lifestyle, and your environment, keep an art journal to record and test your ideas with swatches and thumbnail sketches. Take notice of what lights you up. What common threads keep showing up in your life, your home, your wardrobe? In the things you collect? In the photos you take? Compile the inspiration from things you have around the house, fashion, advertisements, store displays, a walk in your neighborhood, nature, and artwork you love. What do you notice? These are your clues to finding your signature color palette.

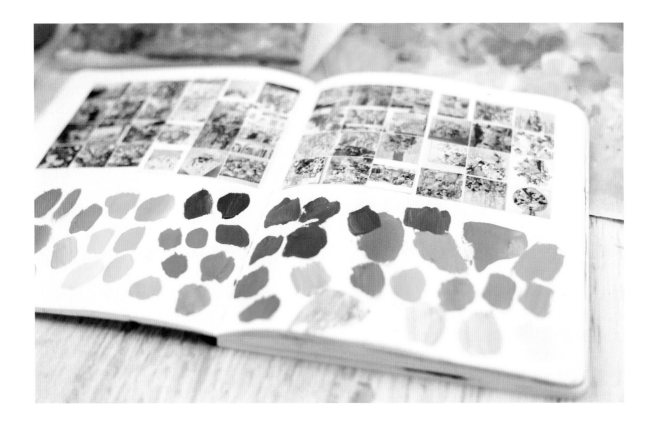

Palette Collecting Exercises

EXERCISE 1

To begin collecting inspiration for your signature color palette, go on a hunt to find examples of what you are drawn to. Snap photos or save images. Group some of your favorites together, and see if you find color palettes that excite you. Here are a few places to look:

- Ephemera: mementos, personal treasures, old cards and books

- Saved images: from Instagram, Pinterest, your computer, magazine pages

- Your closet: clothes, accessories, patterns and designs, favorite outfits

- The junk drawer: packaging, matchboxes, tins, tape, sewing supplies

- Home decor: fabric, wallpaper, throw pillows, tiles, dishes

- Paper goods: wrapping paper, journals, stationery, tags, note cards

- Nature: leaves, moss, cherry blossoms, mushrooms, rock formations, tree bark

EXERCISE 2

Look for clues in the artwork you've made in the last year. What are the most dominant colors you've used? Can you identify combinations that work for you? Which pieces are your favorite because of the colors you used?

Create a grouping of your work (art journals, small works, big canvases) and re-create the colors you see. This serves a dual purpose for training your eye to see color and for noticing your own patterns emerge. Do you see a common thread throughout your work? Do you prefer warm colors or cool? Do you mostly use a saturated palette, or are you drawn to muted, earthy tones? What sparks you as you look at your work? Create swatches of your discoveries so you can have a record of your favorite combinations. This is a map to you and your signature color palette.

EXERCISE 3

Screen capture some of your photo feed on your smartphone and make prints of the photo collage. I do this regularly to see what patterns appear. I organize a photo file on my phone or use a hashtag on my own posts on Instagram to see the work together. (In the photo below, I'm looking at some of my floral pieces plus some inspiration elements.) This allows you to see a color pattern emerge. Using the new mixing skills you'll develop in chapter 3, match those shades with paint so you have a permanent record of your favorite color choices.

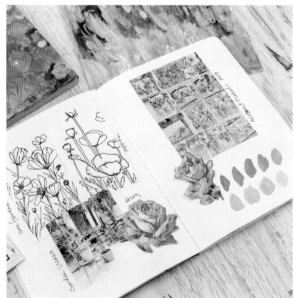

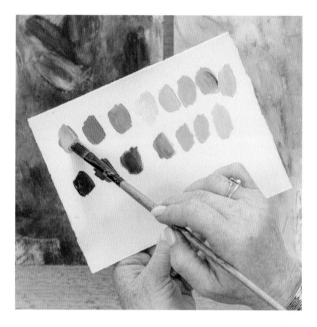

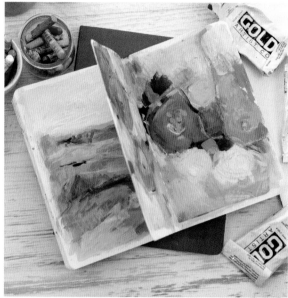

Throughout this book, you'll see that I've created color swatches to remember my paint choices. I often do this in a notebook and include the colors I've used. But the more I've mixed colors, the more savvy I've become in visually identifying which paints I need to achieve the colors I want. While you're still learning to do this by instinct, I recommend keeping a journal of your favorite paint hues and the color mixes you discover along the way. Practice plus repetition will lead you to becoming a good colorist.

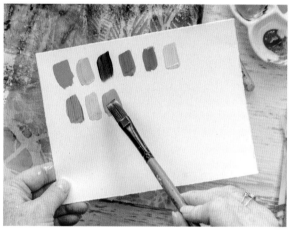

More Art Inspiration
In addition to looking at your own artwork, group together other artists' work that you like, take a screen capture, and print it out for another color reference. You were drawn to these works for more than the subject and style; the colors spoke to you as well. What do they say?

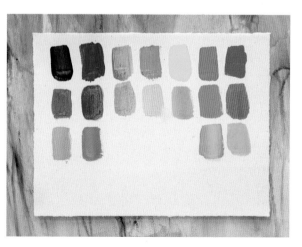

Kellee's Five Color Principles

Sometimes I pick offbeat combinations of blues, reds, and yellows for my palette. But more often, I find myself turning to the colors we use in modern color theory, and I'm satisfied with the results every time. With all this experimenting, I have outlined five principles of color that guide me in my artwork and help me achieve the results I'm searching for.

1 | UNDERSTAND HOW COLOR WORKS: Understand it to your core by doing the work. Understanding color is a lot more than mixing—it's practicing these principles. Knowing how color works in practical application helps you make better artwork. See how the colors react with each other, notice which mixes you like best, observe how they change when you add white or black, and satisfy any other curiosity you have that will propel you toward knowing how color works.

2 | BALANCE THE CHROMA: Chroma is the vibrancy or saturation of your colors. I see pure rainbow colors in paintings all the time, but where do you rest your eyes? If you want your best colors to pop off the canvas, they need to contrast with something subdued. Think about a desaturated rusty orange next to a pop of bright teal. These contrasts in vibrancy create beautiful drama in your artwork. When choosing a palette, consider adding more neutral colors to make bright colors stand out.

3 | COLOR HAS VALUE: Every color belongs somewhere on the value spectrum that goes from light to dark. Yellow is always at the top of my value chart as the lightest hue, and indigo or purple is at the bottom as the darkest. I keep this in mind as I paint so I can push the contrast in my work without using only black or white. Knowing color value ranges helps you select hues with more contrast that offer greater depth to your artwork.

4 | CHOOSE A DOMINANT COLOR: One of the biggest mistakes I see in abstract art is that all colors have the same presence. This leaves nowhere to rest the eye and doesn't create a dynamic focal point. Think most, some, a bit when selecting your palette, and allocate your color use accordingly. One color family will take center stage in your painting while the others take smaller roles, creating a better composition.

5 | LIMIT YOUR PALETTE: Paint is available in hundreds of yummy, rich colors. When you narrow your selection to no more than six colors, you are more likely to achieve color harmony. Colors will work together more cohesively because the mixes are all derived from the same base. That demonstrates your understanding of how to mix colors, which brings us back to the beginning!

My One Guiding Rule of Design: Variation Is Key

Throughout this book, I state one rule over and over again: Variation is key. Don't make everything the same! If you can do that, you can improve your work. I love to go in depth in my retreats and online workshops about the nuances of how to make a standout design; however, it all falls back on this one guiding principle.

Our instinct is to make things symmetrical. But symmetry isn't as natural as you imagine. Even our faces are not perfectly symmetrical. There is beauty in variety, which triggers interest and draws us closer to a subject. This applies to artwork as well. Consider all the elements that you incorporate in your art, and then examine them to see if they are too similar or if the work is varied and contrasting. Similarity produces a boring painting, and differences create excitement. Here are things to consider to keep your work varied:

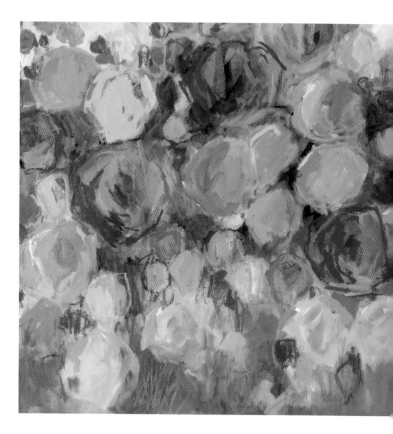

- Are all of your colors midtone hues, or is there a wide range in value from the lightest color to the darkest?

- Do you use the same amount of each color, or are you choosing different proportions?

- Are your brushstrokes the same size and shape, or do you have unexpected marks throughout your work?

- What are the proportions of the subjects in your work? Are they the same size and spaced evenly, or is there diversity in how they're represented?

- Is there breathing space in your work, or is every corner crowded with action?

- Has your composition been broken into even halves or thirds? Or, have you put the primary focus off-center?

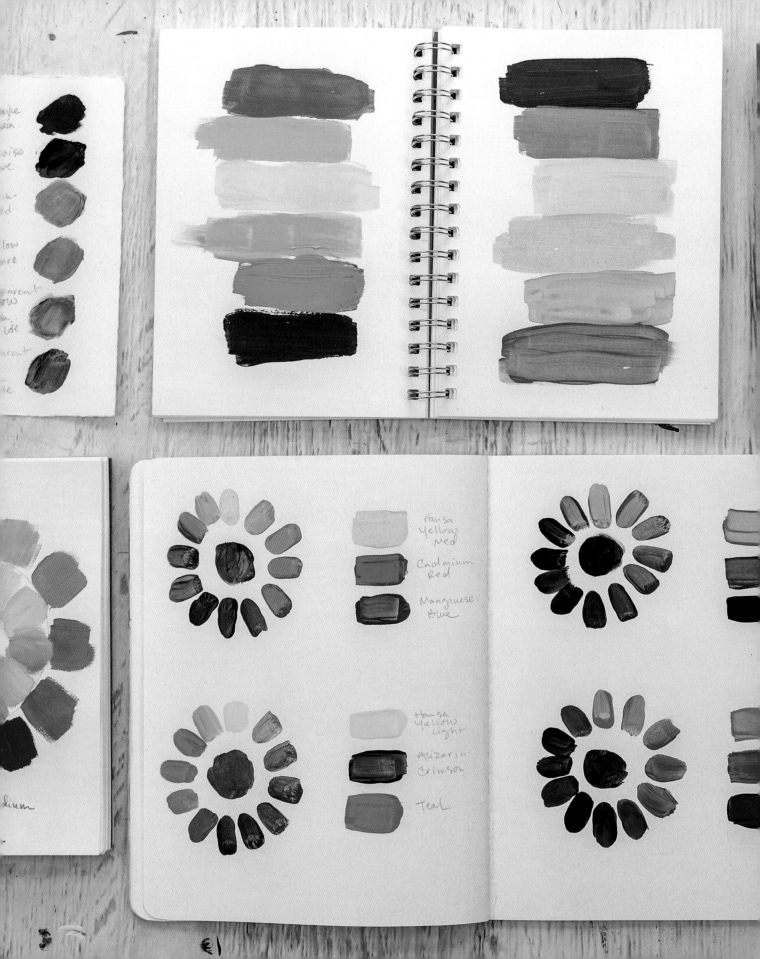

Hansa
Yellow
Med

Cadmium
Red

Manganese
Blue

Hansa
Yellow
Light

Alizarin
Crimson

Teal

3

MODERN COLOR THEORY

I could tell you how light refracts color and explain the science behind the rainbow, but I'm going to skip right past those and just tell you about paint. Paint colors today are vastly different from what was available during Renaissance times. In the last 100 years or so, we've had an abundance of colors to choose from that are available in so many new materials. Previously, color theory included hues such as ultramarine blue, cadmium red, and cadmium yellow. The newer colors of phthalo, quinacridone, and azo yellow are synthetic hues not found in nature and have revolutionized the way we create because they offer an incredible array of colors that you can't get using the traditional color palette.

Many artists have moved over to new and exciting possibilities with modern synthetic colors. This is where modern color theory comes into play. For printing and graphics, and now on your canvas, you can use primary cyan, primary magenta, and primary yellow. Let's take a deep dive together into a whole new world of modern color theory.

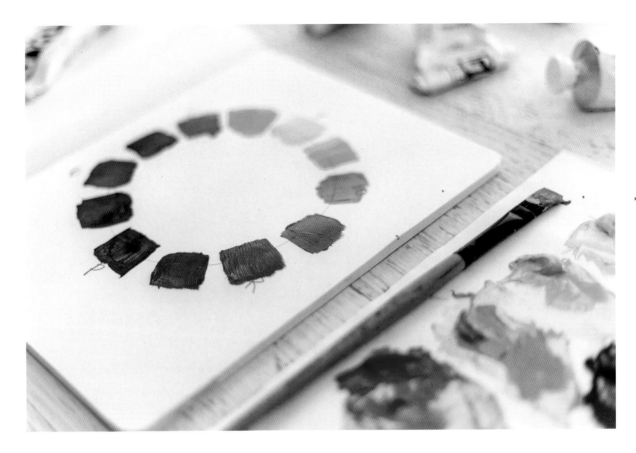

One of my goals in teaching modern color theory is to provide guidelines to help you make better artwork. I don't believe in hard and fast rules but I do know that when we have principles we can easily follow, we can better trust our intuition.

Color theory and the color wheel may seem basic, but they're more than elementary, my dear. They are essential to your growth as an artist and should be practiced and applied. The biggest mistake artists make when learning about color is not taking the time to mix paint colors. You can't learn by looking. When my students say, "Oh, now I get it!" I know they've practiced color-mixing exercises. Mastering color is an action, not an observation.

Using primary cyan, primary magenta, and primary yellow instead of traditional painter's colors—cadmium red, cadmium yellow, and ultramarine blue—has been revolutionary. I can achieve consistency throughout my work by using these three colors, plus white, and my work turns out more vibrant. Through observation and practice, color mixing has become much like cooking—I usually know how the dish will turn out by using the same ingredients every time. I know how the colors will mix and how they'll work in my paintings. It feels good to no longer be challenged by color, and my hope for you is to have the same color confidence I've been able to gain over the years.

Grab your art journal and let's work on some essential warm-ups. We'll put principles to work in these practical exercises.

Color Vocabulary Cheat Sheet

COLOR

PRIMARY COLORS: Red, yellow, blue

SECONDARY COLORS: The resulting hues when primary colors are mixed: orange, purple, green

TERTIARY COLORS: The resulting hues when primary and secondary colors are mixed, such as yellow-orange or blue-green

HUE: Pure color

SHADE: A color mixed with black

TINT: A color mixed with white

TONE: A color mixed with gray

INTENSITY (ALSO CALLED CHROMA OR SATURATION): The purity of a color. You can change a color's intensity by making a shade, tint, or tone of it.

VALUE: A color's range of light to dark to create contrast

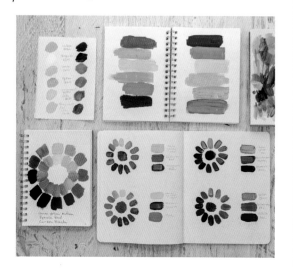

COLOR SCHEMES

MONOCHROMATIC: Using one color and creating variety by mixing shades, tints, and tones

COMPLEMENTARY: Colors opposite one another on the color wheel, such as yellow and purple, orange and blue, red and green

ANALOGOUS: Colors next to each other on the color wheel, such as red, violet, and purple.

TRIADIC: Any three evenly spaced colors on the color wheel

SPLIT COMPLEMENTARY: One color plus the two colors on either side of its complement, such as orange with blue-green and violet-blue

COLOR TEMPERATURE

WARM COLORS: Colors associated with warmth, activity, and light, such as yellow, orange, and red

COOL COLORS: Colors associated with cool, calm, and quiet, such as green, blue, and purple

LET'S EXPERIMENT WITH COLOR

Color Wheel Warm-Up

This color wheel exercise is the beginning of your mixing journey and reinforces the first principle: Know how color works. Pure color right out of the paint tube is exciting and easy. But nothing is as beneficial to understanding color and learning how hues work together than mixing colors yourself. This is where mixing your own colors using only primary cyan, primary magenta, and primary yellow comes into play. By using the CMY modern color theory, we can create an almost endless array of colors, including beautiful teals, vibrant violets, and earthy greens. Creating a basic color wheel is the first step.

After you mix colors using the modern color primaries, try mixing the earth colors and pastels, as well as the classics (ultramarine blue, cadmium red, and cadmium yellow), to see how they differ.

Pro Paint Tip

If your paint dries out as you mix it, spritz it with water on the palette to keep it wet.

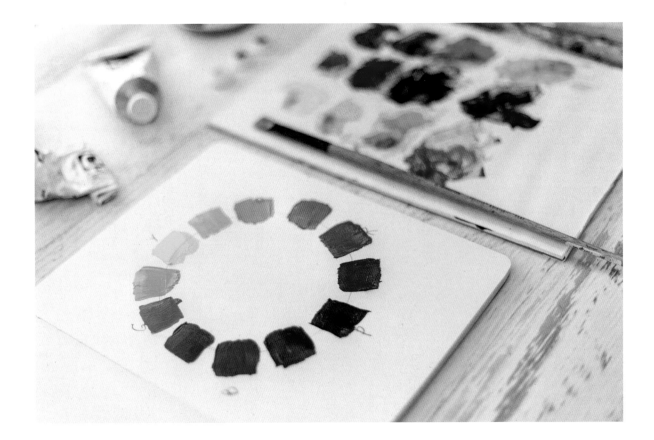

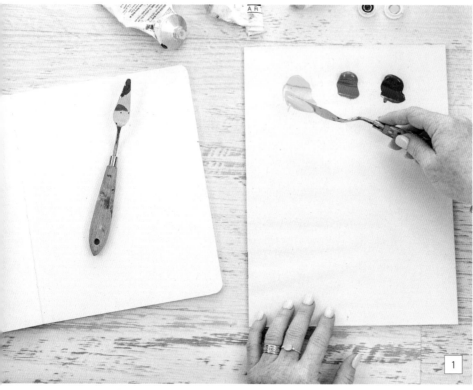

1 | Add the three modern primary colors (primary cyan, primary magenta, and primary yellow) to a palette.

2 | To create secondary colors (orange, purple, and green), mix two of the three paint colors at a time to make a range of colors within each color family.

To make the first range of secondary colors, add a touch of magenta to yellow to make a warm yellow hue. Mix more magenta with yellow to make a pumpkin orange, and add just a little bit of yellow to magenta to make a deep orange that is nearly red in hue.

(continued)

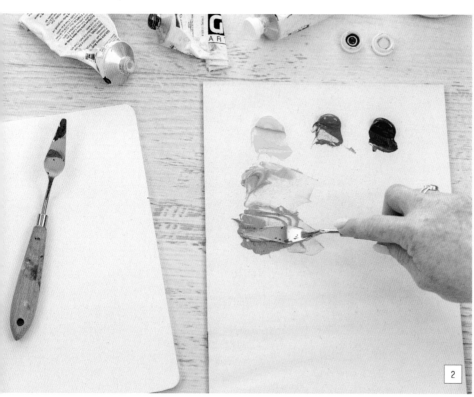

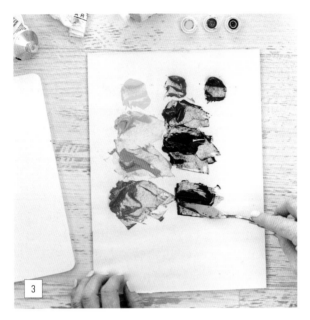

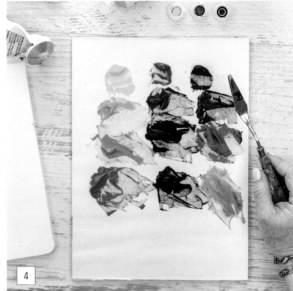

3 | Make three hues of violet by mixing magenta and cyan. Mix a touch of cyan with magenta for a maroon color. For purple, add more cyan to magenta. To make indigo, blend only a touch of magenta with cyan.

4 | For the green variations, mix cyan and yellow. I used mostly yellow and a touch of cyan to make the lightest hue, and then continued adding just a little more cyan to make the darker shades of green. Cyan has a strong tinting strength, so you only need to start with a small amount when mixing with yellow.

5 | Create a color wheel by drawing a large circle in pencil on art paper or in an art journal. Mark the twelve o'clock position with yellow (Y), the two o'clock position with orange (O), the four o'clock position with magenta (R), the six o'clock position with purple (P), the eight o'clock position with cyan (B), and the ten o'clock position with green (G). I always put yellow at the top because it's the lightest color value, and arranging the wheel by value will help us later as we plan our palette.

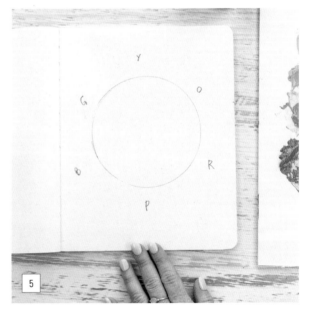

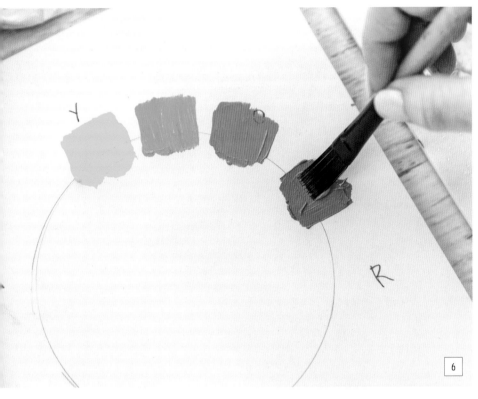

6 | Fill in the wheel, using the three primary shades and the nine colors you just mixed, by brushing swatches of paint along the circle, starting with primary yellow and going clockwise, adding warm yellow, then orange, followed by red-orange, and so on.

7 | Complete the wheel in the order the colors were mixed, and you'll have a wonderful reference for all future projects.

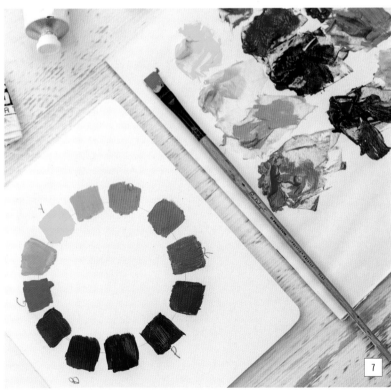

The Benefits of Making Mud

Color saturation can be a powerful tool in drawing your attention to a focal point in a piece. Saturated colors can also inject your work with vibrancy when paired with muted or desaturated colors, often referred to as mud. If you want to make a statement, just a few dabs of vivid color next to a dull background will make a big impact. Overusing highly saturated colors can be jarring or even boring because there is nothing to contrast with the high-chroma hues. Variation is key.

Let's practice making mud on purpose. By toning down vibrant hues, we can balance our paintings with muted colors. We need all the colors of the rainbow for this exercise, so this is perfect to do after creating a color wheel. In order to desaturate a bright hue, choose complementary colors for mixing. Complementary colors are opposite each other on the color wheel.

1 | Using the color wheel as a reference, swatch each complementary color pair side by side on heavy art paper or in your art journal. I started with yellow and purple and orange and blue.

2 | Mix a small amount of each complementary color into the other to mute the intensity. Continue, adding a little at a time to make incremental adjustments.

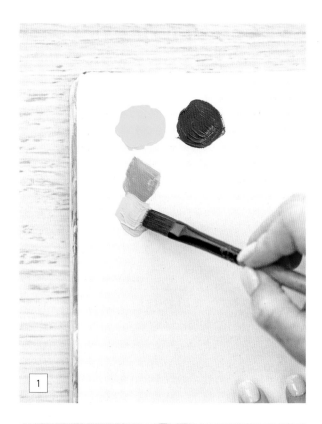

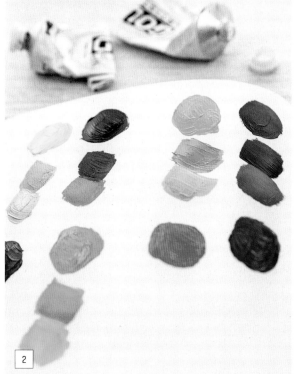

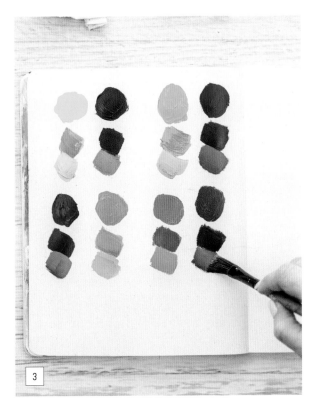

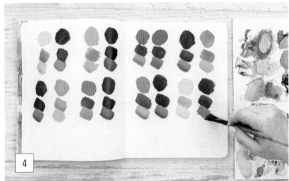

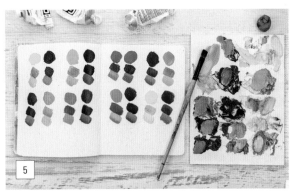

3 | For each muted mix, add varying amounts of white to create lighter values.

4 | Continue to swatch new complementary color combinations, going through the entire color wheel.

5 | Notice how the muted tones compare with the original shades. You'll discover a whole new world of possible color combinations.

Complementary, Not Complimentary

The word "complementary" comes from the word "complete." When we put two complementary colors together, we have completed the color wheel by having all three primaries together. With the complementary colors red and green, for example, green is a mixture of yellow and blue, so we have completed the primary triad.

Color Has Value

Color value plays a key role in the success of your painting. If we think of color as a superhero, lack of a value range is its kryptonite. Without a dynamic value, your paintings will fall flat. Each color you choose will fall somewhere on the value spectrum. Let's look at how a value range on a scale of one to ten works with our palette. Doing this assignment will cement the value range in your mind, allowing you to push the boundaries of contrast more freely and create a better work of art.

1 | Using a pencil, create a ten-square vertical grid in your art journal or on a large sheet of paper. Starting with white acrylic paint at the top and black at the bottom, mix black and white to shift the color in each section to make a gradation. Don't worry if you don't get it right the first time; you can paint over your previous attempt until you make a workable value chart.

2 | Gather your colors (straight from the tube or mixed) and match each color, value-wise, to a shade on the grid.

3 | Yellow will be the lightest shade, and purple or indigo will probably be the darkest. Where do the rest of the colors fall on this scale?

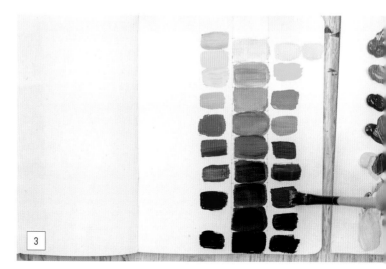

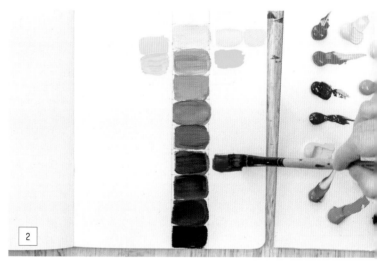

Practicing Scales

A simple way to check a value range is to take a photo of your artwork and convert it to grayscale. This instantly lets you know if you're stuck in a midtone range or if you have found success with creating a range of color values.

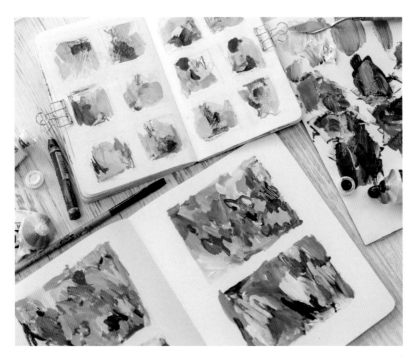

Color Proportion

To achieve overall unity and create emphasis in your artwork, you'll need to decide which colors should be assigned the largest areas and which the smallest. This exercise highlights the design principle that variation is key (see page 31). We want to create interest in our work and actively avoid a perfect balance of all colors. If all colors are represented equally, your painting becomes stagnant.

The easiest way to vary proportions is by using the gallon, pint, cup method. One color family will be used the most in your artwork (gallon), one used slightly less (pint) and the last used the least (cup). If you're not familiar with the imperial measurement system, use most, some, and a bit in place of gallon, pint, and cup.

If you want to take your work from flat to fab, then try this next exercise, which is designed to improve your composition and use of color. We'll use the gallon, pint, cup method to create a simple abstract.

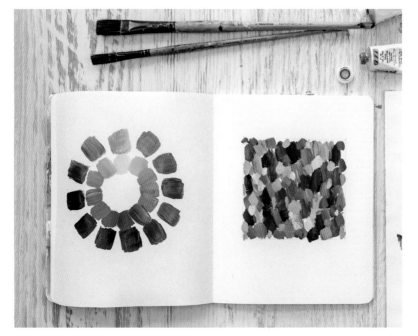

In this photo, you can see that after I chose my color palette, I didn't use proper proportions. I see this problem often: repeating colors equally in nearly the same value range and using similar repetitive marks without giving thought to composition or a focal point. This happens when we don't resist the urge to make everything symmetrical.

1 | Mix a palette of colors using any three primaries, such as the modern color triad or any red, yellow, and blue. I used Indian yellow hue, quinacridone magenta, and Prussian blue, plus titanium white. Optional: Fill out the color wheel with your colors.

2 | Before you begin painting, block out four squares in a spread in your art journal so you can practice this proportion exercise several times. Decide which colors in your palette will be dominant and which will play a minor role for each square. For the first square, I chose to start with warm colors to make a prominent statement with pink and orange. I'm painting in an abstract manner so I can focus on the composition.

3 | Now that the dominant colors are in place, add colors that play a smaller role. I chose complementary colors of dark green, light yellow green, and pastel blue-green. I added them using smaller brushstokes to avoid painting even amounts.

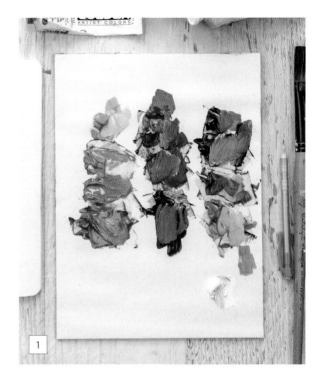

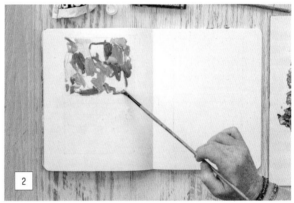

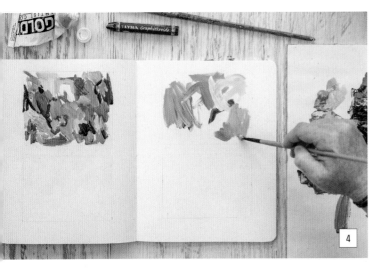

4 | In the second practice square, while the brush is already filled with paint, add the minor colors from the first square. But this time, use them as the major color focus, placing them in a dominant role.

5 | Continue painting the composition for the second square just as you did with the first by choosing complementary colors. This makes our dominant color yellow and violet-red our minor player. Can you see what an impact such a small amount makes?

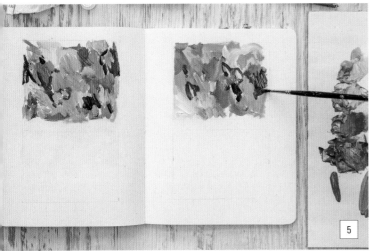

6 | Continue the same pattern of gallon, pint, cup for the last two sections, choosing different proportions from the same palette each time. It may seem like you're making random marks as you paint, but pay close attention to your design. The brushstrokes may be intuitive and an expression of your hand, but it's still important to create a strong composition. This principle of proportion is vital and will instantly help you be more successful.

Be mindful of not only the proportions of each color but also their values. Don't forget to use white to lighten your initial mixes.

This exercise can be repeated as many times as you wish and in as many squares as satisfies your need to explore. I love making small-square grids to practice my five color principles (see page 30) and my variation-is-key principle of design.

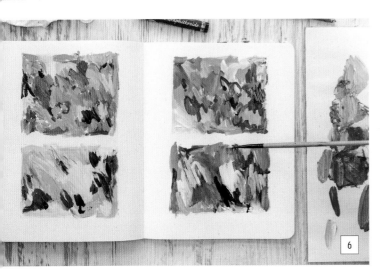

Alternative Primaries

Now that you've learned the foundation of my modern color theory method by mixing primary cyan, primary magenta, and primary yellow, let's turn the idea on its head and begin creating new and exciting palettes using any three primary colors. We'll explore color possibilities by mixing up random and unique combinations of blue, red, and yellow—with some strange alternatives.

This exercise will be eye-opening and exciting and might revolutionize your understanding of color even more than mixing the traditional color wheel. It will teach you how color works in each mixing experiment and show that you can create great art with a limited palette. By limiting yourself to three colors plus white, you'll see how many variations you can achieve while still creating a harmonious palette.

Try these primary combinations or choose one of your own, and relax into a meditative spell of mixing paint:

- Hansa yellow medium, cadmium red, manganese blue

- Hansa yellow light, alizarin crimson, teal

- Indian yellow, quinacridone magenta, Prussian blue

- Yellow ochre, quinacridone red, phthalo blue

- Aureolin yellow, transparent red oxide, cerulean blue

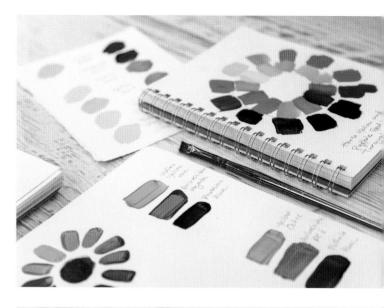

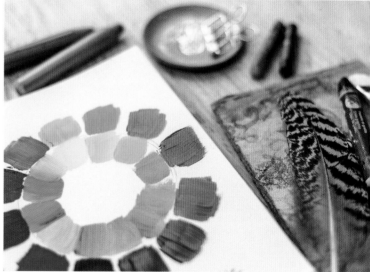

Color Mixing Experiments

Now that you've created a basic color wheel, it's time to dig deeper. Let's see what happens when you mix these colors in new and different ways. There is no better way to learn than to play! Try a few of these ideas:

1 | Mix cyan and a tiny bit of yellow with a touch of white to make a beautiful blue-green. You've created a custom shade of teal!

2 | Add white to any violet to create lavender. Do you like a bright lilac, or do you prefer a muted purple? Adding a little bit of the opposite color on the color wheel will tone the color down and make a plum-purple.

3 | Try mixing a unique shade of brown by using all three primary colors. Is the color almost black? What happens if you add white? Which version of brown do you prefer?

4 | Tone down an electric green by adding a touch of magenta or orange. See if you can create a more natural shade of green.

5 | Adding white to red-orange can make a beautiful coral color.

6 | Make gray by mixing colors that are opposite each other on the color wheel: cyan and orange, magenta and green, yellow and violet. Add white, and you'll have lovely, rich gray tones.

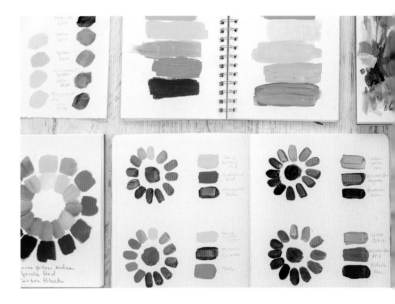

7 | Create perfect tints of pink with red and magenta plus white. Which one speaks to you?

8 | Here are some ideas for changing yellow hues: For greenish-yellow colors, add white to get a cool lemony yellow. For orange-yellow, add white to get a nice buttery yellow. Which of these do you prefer?

9 | How do colors shift if you add a bit of black to them? How does that compare with mixing complementary colors to make gray?

10 | Try your own combinations, record them in your art journal, and share your results.

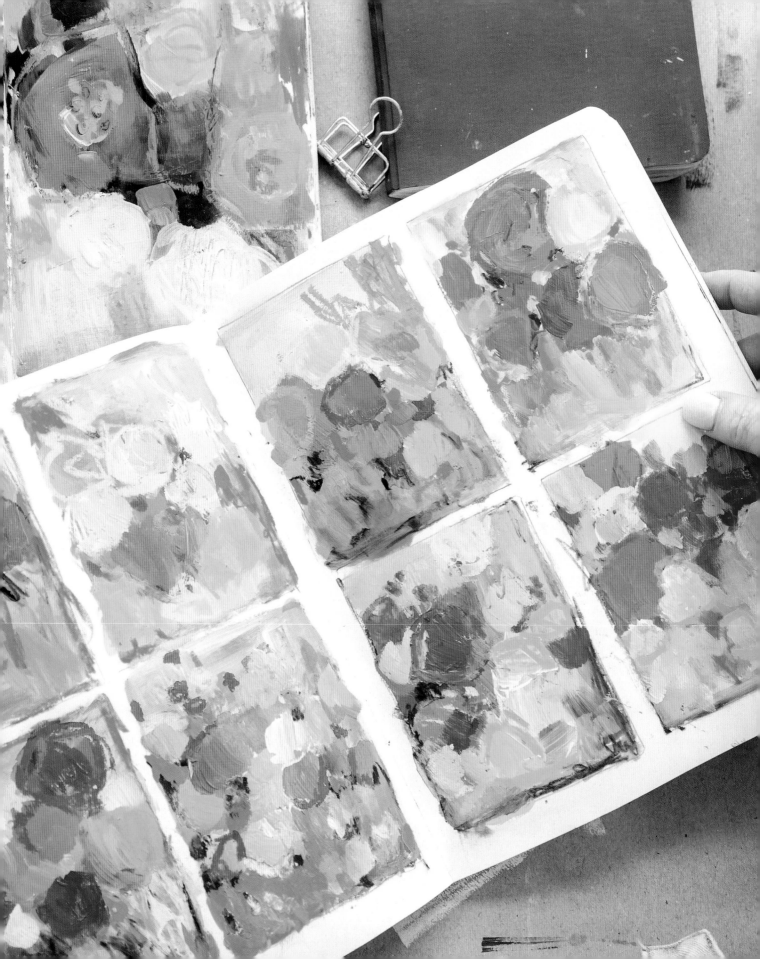

4

PALETTES
AND PROJECTS

I am so excited to introduce you to some of my signature painting styles. Over the years, I've fallen in love with more than just color—I love the process of making art. My process includes building layers and texture and getting lost in the nuances of how materials relate to each other. The following projects are designed to be technique-rich and informative, but they're also a way to have fun and explore your creativity.

We'll incorporate the principles of modern color theory and address common challenges with color. After years of using color in practical applications, my color choices are very deliberate. This doesn't mean there's no spontaneity. Choosing harmonious color palettes in advance means you will struggle less and be able to focus on the process more.

One of the greatest pleasures in working with mixed media is that painting in layers is forgiving. You can correct mistakes and adjust your work along the way by experimenting with different mediums and mark-making tools. Be creative in your approach—use what you have—and substitutions are allowed. Nothing is a mistake in the process of making art. If something doesn't go as planned, consider it serendipity, a chance to discover something unexpected in making your most authentic artwork.

1 COMPLEMENTARY SUCCESS

PROJECT: PAINTED POSTCARDS

There's no quicker way to make an impact with your artwork than to work with colors that are opposite each other on the color wheel. Always a favorite combination, complementary colors naturally lead to a visually pleasing painting. While we're using an opposites-attract approach in this lesson by using pure hues, it's important to note that the tints, tones, and shades of each complement are just as beautiful together. If you're using these techniques to create a larger painting, consider principle 2 of my five principles of color: balance the chroma. Choose one color to dominate, and consider muting its opposite to create a more pleasing work of art.

Since rules are meant to be broken, we will break the commonly understood rule of not using too many saturated colors in this project. Postcards are a small space to work within, and bold colors will make an impact. One of my favorite upcycled projects is to sketch on vintage postcards, which is also a good mixed media warm-up. My postcard collection comes from booksellers along the River Seine in Paris and also from the city's fabulous flea markets. You can easily find vintage postcards on Etsy. I seek out ones that have postage and have been written on. They tell a story, and many are more than 100 years old. What treasures!

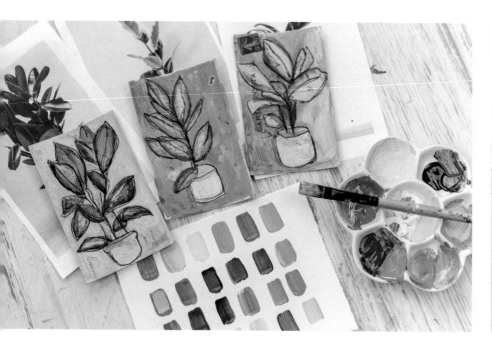

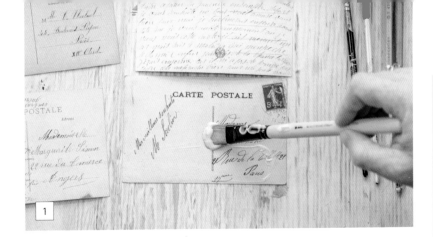

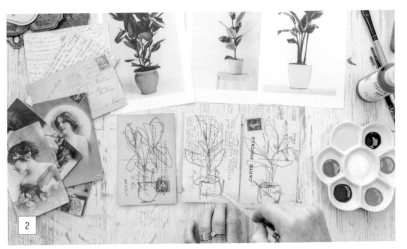

MATERIALS

- Postcards (vintage postcards with writing work especially well for this project)

- Paintbrushes

- Fluid matte gel medium

- Heavy books or weights (optional)

- Design references (optional)

- Drawing pencil

- Permanent ink pen

- Fluid acrylic paint (or heavier acrylic paints thinned with a fluid medium such as GAC 100)

1 | Choose three postcards to work on simultaneously to experiment with different color palettes. To preserve any writing on the postcards and provide a durable base, brush on a substantial coat of fluid matte gel medium and allow to dry thoroughly. If your postcards curl when the matte medium dries, put them between pages of a heavy book to flatten them.

2 | If you are confident in your drawing skills, draw a simple design with a pencil. I often work with references from the internet or from my own photos. Anything that strikes your fancy can be drawn easily. I created single-line contour drawings of basic plant images, using photo references. To make a single-line contour drawing, draw without lifting your pencil off the page. This keeps the design fresh and somewhat abstract, and it's an easy technique that allows you to express yourself without getting caught up in the details.

(continued)

3 | Trace over the pencil with a permanent ink pen (such as a Faber-Castell PITT pen) to accentuate the contour drawing and give it a modern look.

4 | This step is key to making these simple works pop. Referencing your color wheel from chapter 3, choose complementary colors for your subjects and backgrounds, such as purple and yellow, red and green, or blue and orange. Using a small brush and fluid acrylic paint, paint the shapes and the background in thin layers, glazing them with the contrasting colors. If you don't have fluid paint, mix heavy-body paint with a fluid extender medium, such as GAC 100, until the consistency resembles heavy cream.

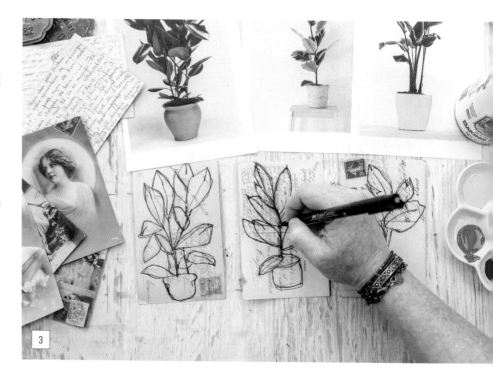

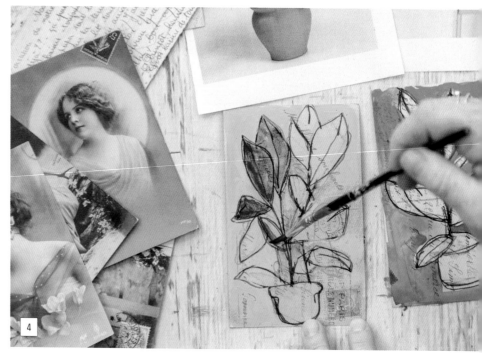

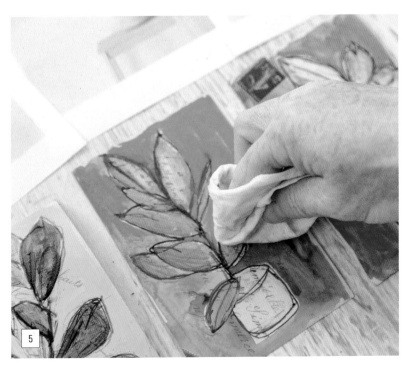

5 | Blot some of the color as you go to make sure the layers stay transparent, revealing the writing underneath.

6 | Layer the paint, using analogous colors (adjacent on the color wheel) to create more depth. For example, on the green leaves, I added yellow for light value and blue for dark value, but the leaves still look green overall. Continue to add color and details in luminous layers until the pieces become dimensional and interesting.

(continued)

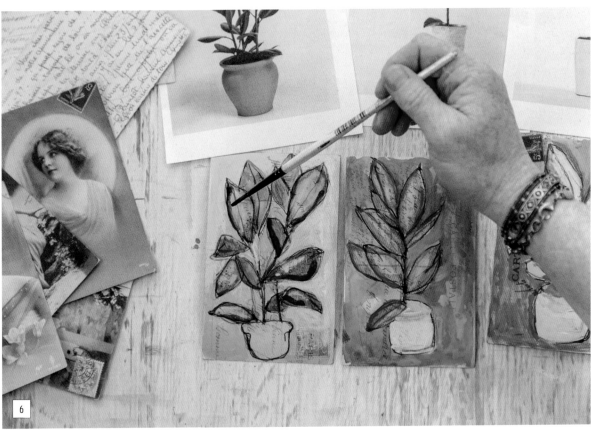

7 | After the paint is completely dry, go back with the permanent black pen to emphasize the line work and make it more defined.

8 | Make a chart of all the color possibilities to make a reference for future paintings. The process of choosing complementary colors is as nuanced as there are variations in each color.

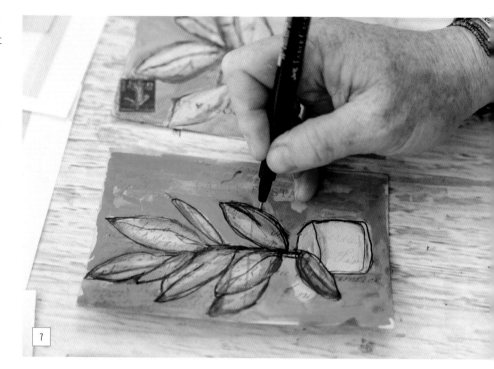

Tip

Making a Colorful Statement

Paint your subjects in contrasting hues, which will make a bold statement. If you drew plants or something similar, you won't be using naturally occurring colors. Go ahead, you have permission!

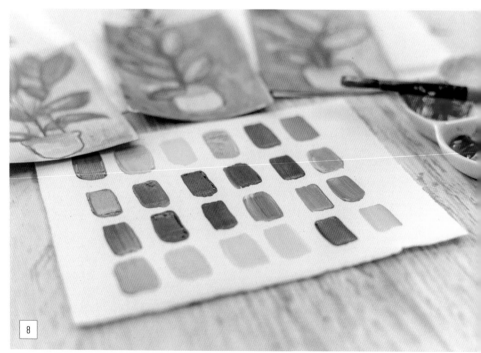

Guest Artist: ALICE SHERIDAN

"Tamarind Fiesta"
12" × 12" (30 × 30 cm),
acrylic on wood panel
Website:
alicesheridan.com
Instagram:
@alicesheridanstudio

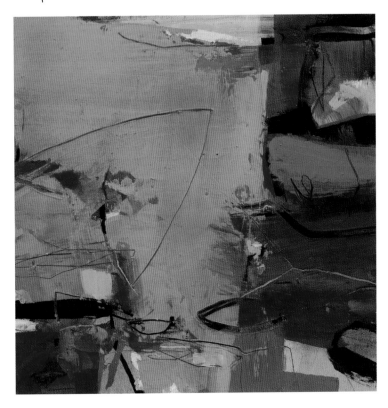

In any painting, color is both my biggest joy and biggest frustration. Mixing paint to create my own colors is so sensory, and the opportunity is always there to create something unique. The urge to create color was what pulled me back to painting from printmaking, where I learned to explore the creation of surface texture from acid and metal. Now, in my work, I like to combine this with trying to juggle both a restraint and a lusciousness of color.

The range of color available to us is endless, and when the human eye can pick up even the tiniest nuance of color, that can bring some difficulties too. I'm always learning which pigments will create the color I hold in my mind. I think the color we are drawn to use is deeply personal and is influenced by our climate, geography, personal history, and personality. I love muted squashed fruit colors as well as autumn colors, such as moss greens, burnt oranges, and smoky blues. But I also like to leave room for surprises and use sparks of more intense color or allow a color to take over.

Color is all about relationships, and these grow within a painting. I may begin using similar colors. But at some point, one will invariably take over, and my job is to fine-tune how they all work together. There are so many possibilities, but there is no need to squish them all into one painting.

FROM DARK TO LIGHT

PROJECT: ABSTRACT LANDSCAPE

I stand by my assertion that color is the primary reason we are drawn to a painting, but I concede that without value, color doesn't hold much weight. We need contrast to create interest; otherwise, artwork with only midtones will be lackluster. In this lesson, we'll incorporate the techniques from the warm-up lesson in chapter 3: Color Has Value (see page 42).

Blue and brown hues will be used for darker values, orange for midrange shades, and yellow and gold for the lightest values. We'll build layers of paint and add collage and stenciling for depth and interest. These techniques create stark contrasts and show how to use color to create a beautiful range of values in your artwork.

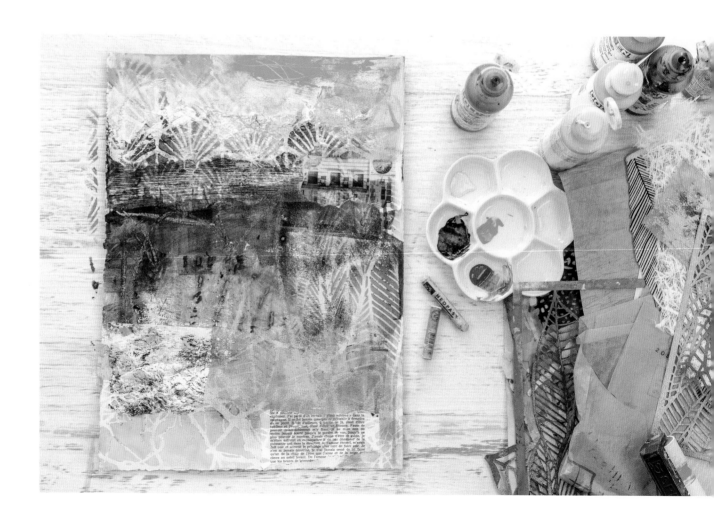

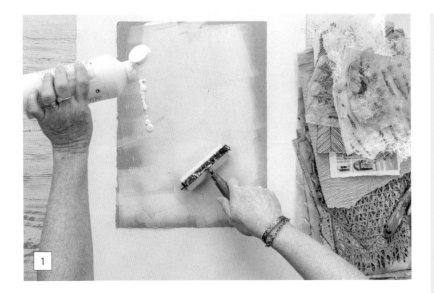

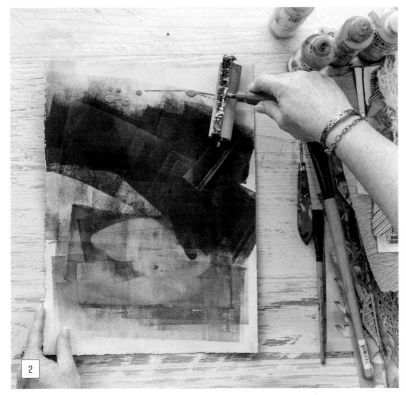

MATERIALS

- Smooth kraft-color print-making paper (I used a 11" × 15" [28 × 38 cm] piece of paper torn from the quarters of a large piece of Stonehenge paper)
- White gesso
- Acrylic paint
- Brayer
- Collage papers
- Heavy-body gel medium
- Plastic key card or expired gift card
- Stencils
- Paintbrushes
- Oil pastels

1 | Roll a thin layer of white gesso onto a piece of smooth, kraft-color printmaking paper. This prepares the surface for the next layers of color. Since we love texture, the gesso does not need to be even.

2 | Roll on a few paint colors that represent medium and dark values. Spread them in uneven amounts, and create a horizon line at the top third of the paper for the landscape composition. I used brown for the darkest value and teal and quinacridone azo gold for the midrange values. Let each layer dry before adding the next.

(continued)

3 | With a brayer, lighten up the colors a bit by adding a thin layer of Titan buff or cream paint. To make sure the layer is not too heavy, put some paint on a palette, roll the brayer in the paint, and then roll some of the paint off before adding soft touches to the painting.

4 | Select collage elements that coordinate with your palette and the mood of your piece (see page 17 for more information on making and collecting collage papers). Be thoughtful about where you will be placing the collage papers. Think about composition rather than placing things randomly. Your collage papers should cover no more than half of the substrate. Use your intuition for what to cover and which paint marks are worth leaving exposed.

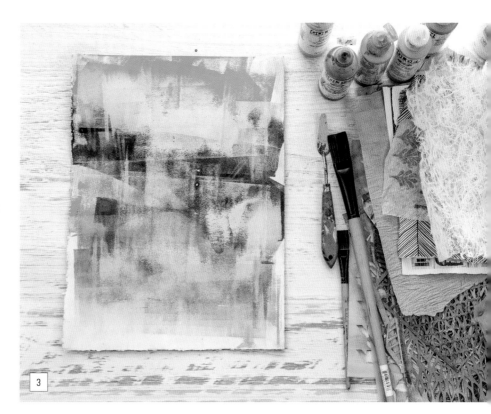

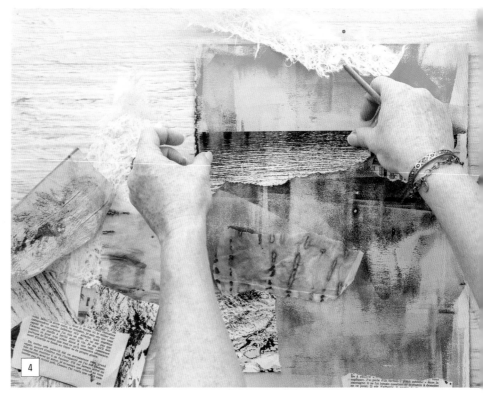

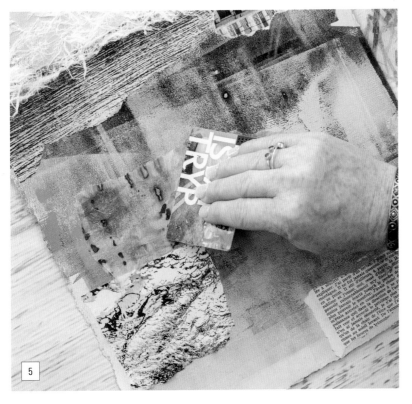

5 | Use a heavy-body gel medium and a brush to fuse the papers to the surface. Make sure the edges of the papers are adhered. Repurposed key or gift cards work well to flatten out the papers as they are attached. Allow to dry.

6 | Choose stencils the same way you did collage material and think about the composition. Stencils with organic designs work well in landscape paintings, because organic and nature naturally come together in harmony. Use an old, stiff, dry brush and dab it in the paint, brushing off excess paint onto waste paper before stenciling. Gently brush it over the stencil for a feathered effect.

(continued)

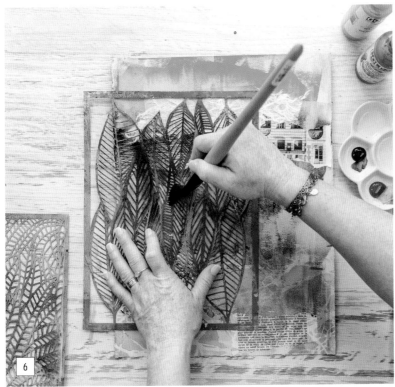

Less Is More
Do not paint the entire stencil image onto your artwork, or it will look very contrived. Create soft, organic edges instead by feathering out the paint and stopping before you fill in the whole stencil.

7 | Being thoughtful of color values, add dark blue to the painting if more contrast is needed. The purpose of this exercise is to use color to enhance a painting with dynamic value.

8 | While the paint is wet, run oil pastel through the paint to leave marks of contrasting values, colors, and textures. This technique can be a little tricky because the oil and water might want to stay separated, but it's completely satisfying when it works out. In this example, I used orange to draw through the turquoise.

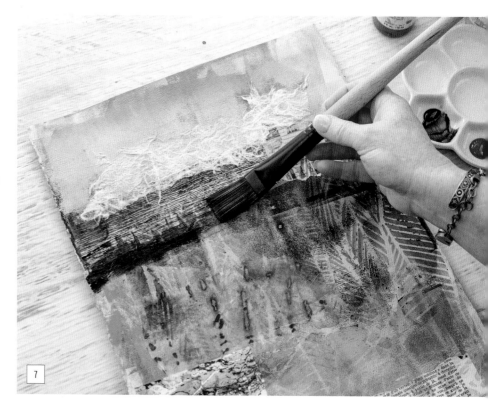

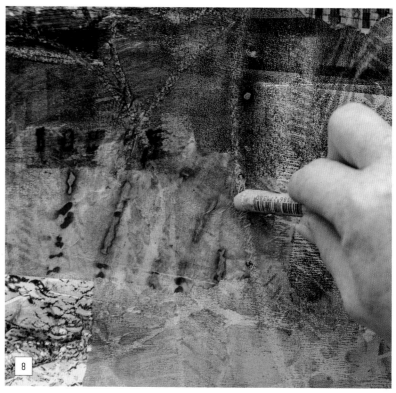

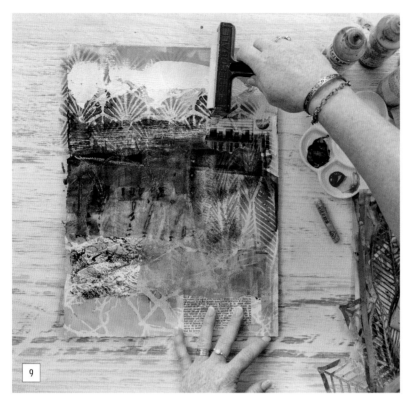

9 | If any part of the composition is too bold in contrast to the rest of the painting, you can tone it down with a very thin layer of white paint so that you can still see the layers beneath.

10 | Add final marks and details to carry the eye through the work.

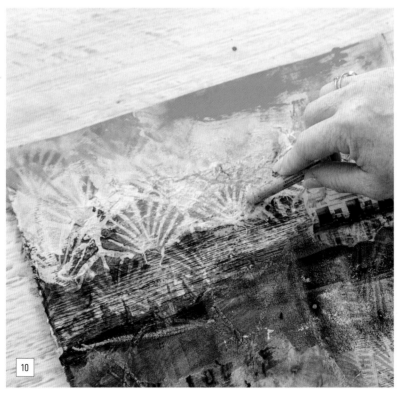

3 HIGH-KEY/LOW-KEY

PROJECT: MOODY ABSTRACTS

Creating a good color value range doesn't mean having to hit all the notes. Sometimes a great composition can be achieved through a range of only light colors or only dark colors, called high-key and low-key. The goal is to keep variation within the range of values you're using. The pleasure in creating limited-value work is that it can convey a specific mood quickly. Dark tones convey a brooding, somber, intimate, or mysterious atmosphere, and light values create a joyous, spacious, energetic, or light-hearted feeling.

For this project, we'll create two mixed media abstracts simultaneously—one high-key and one low-key—using graphite, acrylic paint, stencils, alcohol inks, and a smaller range of colors.

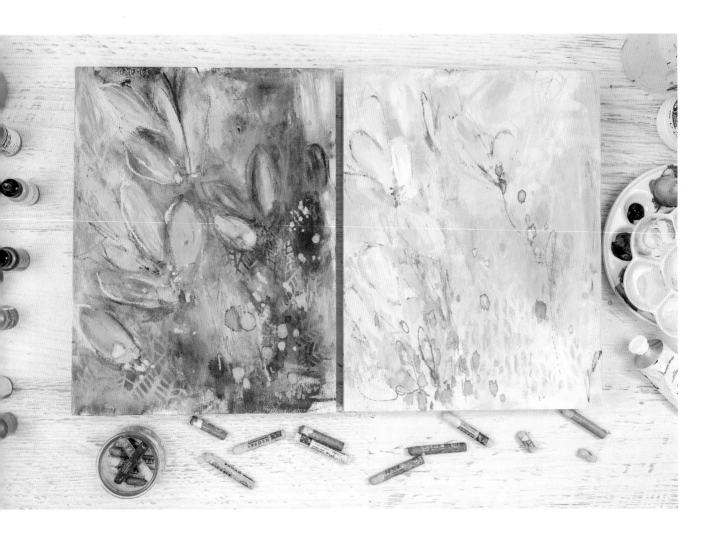

1

2

MATERIALS

- Acrylic paints
- Two cradled wood panels (I used 9" × 12" [23 × 30 cm] panels)
- Paintbrushes
- Clear gesso
- Brayer
- White gesso
- Mark-making tools, such as graphite sticks
- Fixative spray
- Stencil
- Alcohol ink
- Protective gloves
- Oil pastels

1 | Create one high-key and one low-key color palette using a limited selection of colors in the same family but with different value ranges. For example, I used pastel green, orange, and pink for my high-key colors and dark green, orange, and crimson for my low-key colors.

2 | Prepare the surface of the wood panels by brushing a coat of clear gesso on each. This protects the surface and allows the natural wood to show through in spots. Allow to dry. With a brayer, spread a thin layer of white gesso on each panel. Don't cover the entire surface. Create texture and irregular marks by rolling the brayer back and forth. We are all about texture! Allow the gesso to dry.

(continued)

3 | Add a light color, such as Titan buff, to one board and a darker color, such as brown, to the other. Use the brayer to apply thin layers.

4 | Now the fun starts. Using your favorite mark-making tool, create organic marks on your surface. I used a water-soluble graphite stick because it's unpredictable and leaves lovely marks.

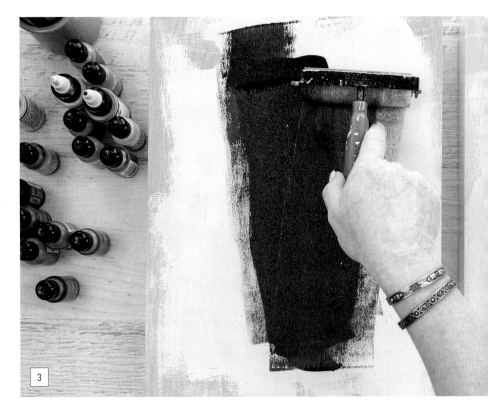

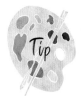

Quick Fix
Use a casein-based fixative spray, such as SpectraFix, to seal water-soluble marks and prevent them from bleeding through subsequent layers.

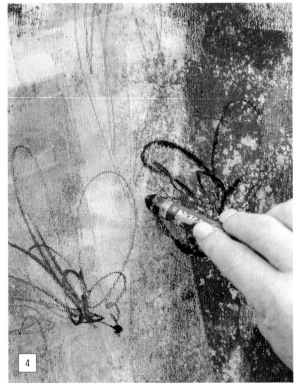

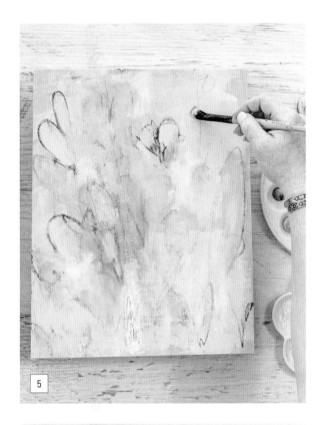

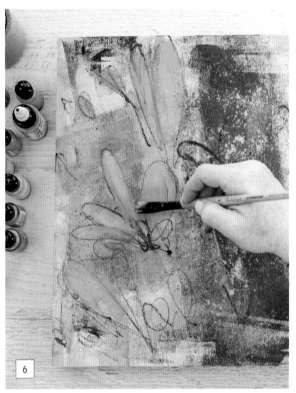

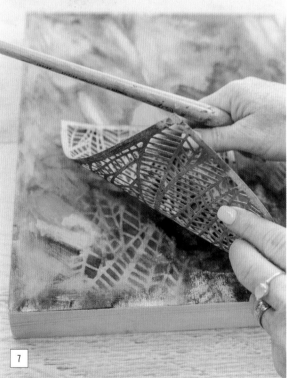

5 | Begin to add color. The best way to build a beautiful range of depth in your artwork is to add thin layers of paint, being mindful to use darker colors on your low-key painting and lighter colors on your high-key painting.

6 | Build more layers and continue to make sure you're using variation within the value range in each painting.

7 | Add stencil designs to your work. Stenciling is a great way to increase depth and texture. Use a stiff, dry brush with a small amount of paint to gently brush over the stencil for a feathered effect. Apply to no more than half of your surface and use as much of the stencil design as you would like, as long as you don't leave any hard edges. Use a contrasting color, usually darker than the surface.

(continued)

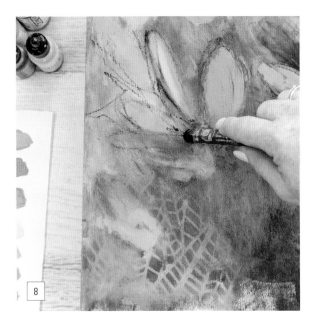

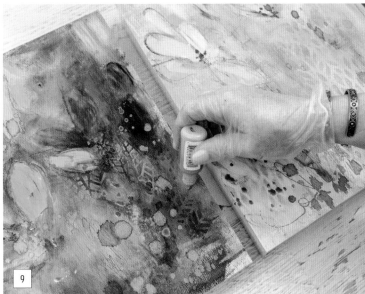

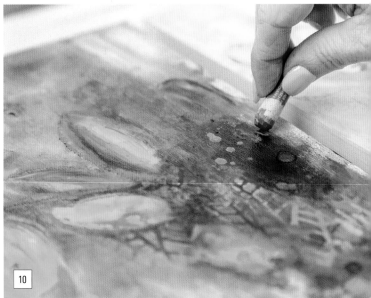

8 | Using the graphite stick, build up the organic shapes with bold sketch lines. Instead of creating even marks throughout the painting, choose a focal point and emphasize it with the graphite. If desired, you may spray with fixative again, or just allow the next layers to react with the graphite.

9 | Add an unexpected twist. Drop, drip, and splatter coordinating colors of alcohol ink in select areas of your artwork. Work in a well-ventilated area and wear protective gloves, since the inks can stain easily.

10 | For some final pops of color, create small, bold marks through the painting with an oil pastel. Use coordinating colors so the contrast is subtle but noticeable enough to create interest.

Guest Artist: PRISCILLA GEORGE

"Bahama Bay"
8" × 10" (20 × 25 cm),
gouache on watercolor paper
Website:
priscillageorge.com
Instagram:
@priscillageorgeart

In the painting "Bahama Bay," a bold magenta-colored plant stands out against a teal background. When choosing these colors, I started by focusing on what color plant I wanted to create: a leafy magenta plant. After selecting the main color for the plant, I focused on picking a highlight color that would make the closest sunlit leaves stand out the most. I thought a soft, warm rose color would be the best choice to keep the plant looking magenta while bringing those leaves forward. There needed to be some contrast in the leaves to push some further to the back and add some drama. For the darker leaves, I painted some edges with Hooker's green and added a bold pop of color to the other side with a lovely lilac purple. To add a bit more warmth to the brightest leaves, I painted just a dab of tangerine to create a luminous quality. The background was my last addition. I love to create a juxtaposition in my paintings. The plant is composed of primary warm tones, so to make the plant pop, a cool teal background was the perfect choice to create a visual impact.

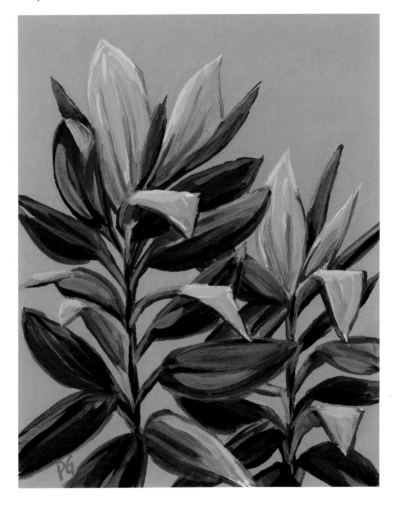

4 COLORFUL NEUTRALS

PROJECT: ARCHITECTURAL ARCHES

Gray is sometimes thought of as a boring color. But, when grays are mixed properly, you can achieve amazing colorful neutrals. Gray isn't just black and white mixed together. It's a rich world of muted colors. Add white and you have colorful neutrals. We can layer these muted colors to create a lush current of implied color.

In Making Mud (see page 40) you learned how to easily desaturate a hue by using its complementary color. You can make a blend of your own grayed color or use a few right from the bottle, like Titan pale green, Van Dyke brown, or my favorite yellow ochre. Metallics also work as amazingly well as neutrals. Just keep the softer side of color in mind as you select paint for this project.

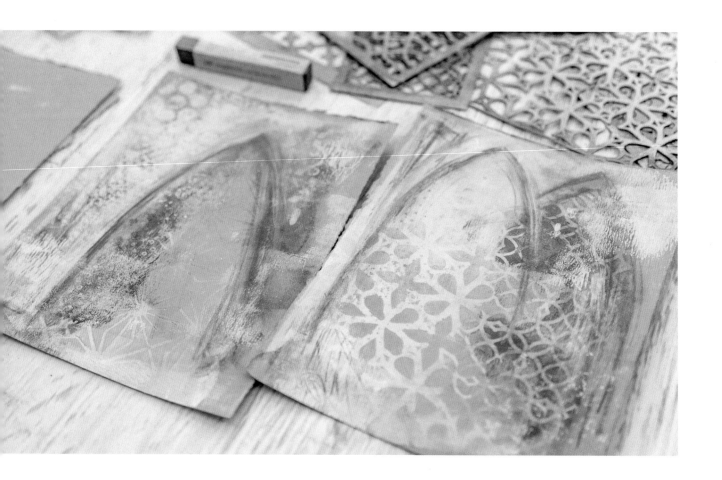

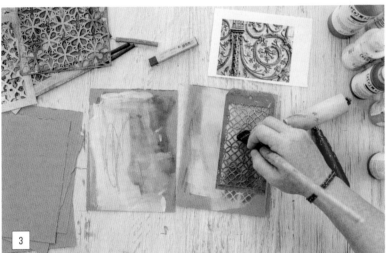

MATERIALS

- Kraft-color art paper
 (I used a 5" × 7"
 [13 × 18 cm] size sheet)

- Water-soluble
 graphite pencil

- Reference images
 (optional)

- White gesso

- Brayer

- Stencil

- Paintbrush

- Acrylic paints in natural
 muted colors such as Van
 Dyke brown, Titan buff,
 black, and metallic bronze

- Water (optional)

- Metallic media, such as
 acrylic paint, paint pens,
 or gold leaf

1 | Tear kraft color paper into small pieces (see page 20). You can use any color paper, even white, and add more neutral paint layers to your mix.

2 | Loosely draw an arch on the paper with water-soluble graphite. If you are unsure about the details of the arch you wish to sketch, print out some images to use as a reference. Keep in mind that we're creating an abstract impression, not drawing precise architecture.

With a brayer, add a thin layer of white gesso to the paper without covering everything up. The whole point of working in layers is to allow previous marks and images to peek through to make the piece more interesting. The gesso also activates the water-soluble graphite, which has unpredictable but beautiful effects.

3 | Stencil over the gesso in spots, using natural muted colors of acrylic paint. I use a dry-brush technique, adding very little paint to keep it from bleeding under the stencil. Use an old, stiff, dry brush and dab it in the paint, brushing off excess paint onto waste paper before stenciling.

(continued)

4 | Although we're using muted colors, value is still an essential design element. With a brayer, roll out a few drops of a darker color, such as Van Dyke brown, gray, or metallic bronze, onto areas of the paper. Continue to add more paint layers, more stenciling, and always keep in mind that variation is key.

5 | By now, your original arch sketch has probably disappeared. Make a few new graphite marks along the same arch you've been working on, and activate them with paint or water to make them darker. Remember, this is meant to be a loose sketch of architecture, not an exact study.

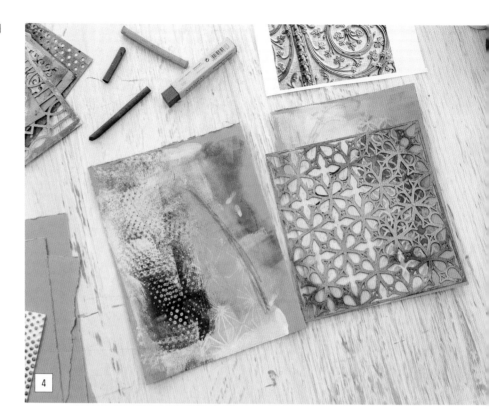

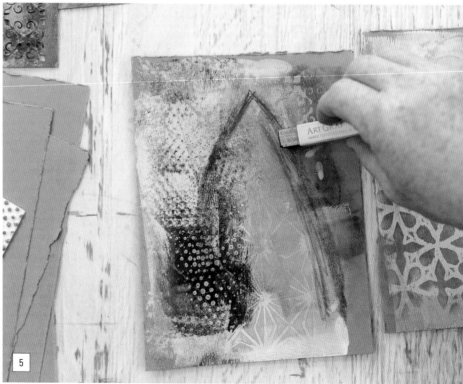

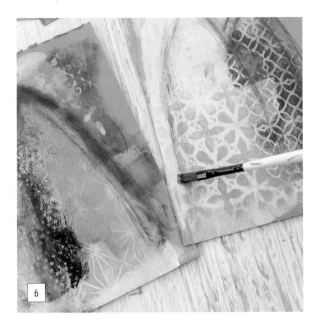

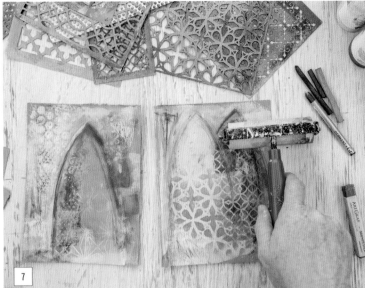

6 | Once an abstract image of an arch begins to appear, begin adding gilded details. Shimmery gold or bronze paint, a metallic paint pen, or gold leaf creates the perfect accessory to your piece.

7 | Notice what your eye is drawn to, and decide if you need to soften any strong lines with a light brayer coat of white paint or make other areas pop out with a darker value or marks. The most important outcome is to see that you can make a painting that feels rich in color while still using neutrals.

Graphite marks are a great way to add depth to a piece.

5 CHROMA POP

PROJECT: PAINTED PORTAL

We may be drawn to vibrant colors, but a common mistake in painting is to use only pure hues. Pure saturation leaves no area for the eye to rest and offers nothing that makes an impact. Placing a strong contrast of neutral colors next to saturated colors makes a significant impression.

We'll explore what happens when we use Portuguese tile patterns and mostly neutral colors to make one bright color pop. This project works for any subject, but I focused on the rough texture of an old door from Lisbon.

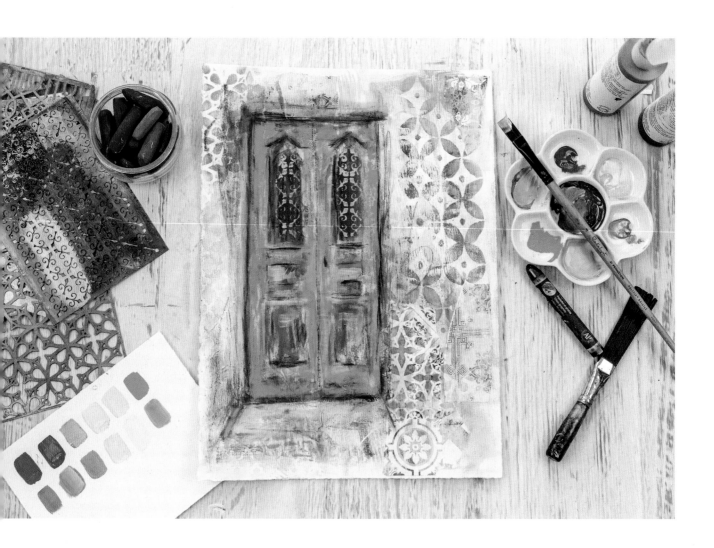

1

2

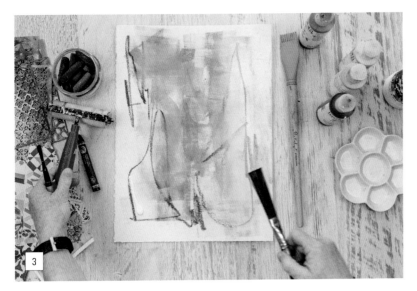
3

MATERIALS

- Stonehenge paper in cream (I used an 11" × 14" [28 × 36 cm] sheet)
- Brayer
- White gesso
- Acrylic paints, including metallic bronze and gold
- Chalk pastels
- Texture tools
- Paintbrushes
- Stencil
- Collage papers
- Heavy matte medium
- Water-soluble graphite
- Reference image (optional)
- Water

1 | Using a brayer, cover the majority of the paper with a layer of white gesso and a little bit of metallic bronze paint.

2 | Mark on the page, using soft pastel, sometimes called chalk pastel. This is the fun part of mixed media, where you can distress the page.

3 | With a brayer, lightly paint more layers over your marks, allowing them to blend. Texture is one of my favorite ways to create dimension. Use found items or tools to run through the wet paint or dip into colors and scumble across the surface.

(continued)

4 | Use a dry-brush technique and neutral shades of acrylic paint to add portions of stencil designs for a beautiful soft, hazy look (see page 69 for the dry-brush technique). Allow the paint to dry.

5 | Add collage elements to the page, continuing to build up the neutral background. Learn to have a discerning eye for where they flow best. Often artists begin by randomly adding collage pieces in a haphazard fashion to their page. Be thoughtful in your composition by using the marks that are already on your surface and thinking about the design that comes next.

For this project, I was inspired by my photos of Portuguese tiles and used my handmade gel-printed papers (see page 18 for instructions on making gel-printed papers). Use a heavy-body matte medium to adhere the papers so they won't wrinkle too much. Often artists just begin by randomly adding collage pieces in a haphazard fashion to their page. Be thoughtful of your composition by using the marks that are already on your surface and think about the design that comes next.

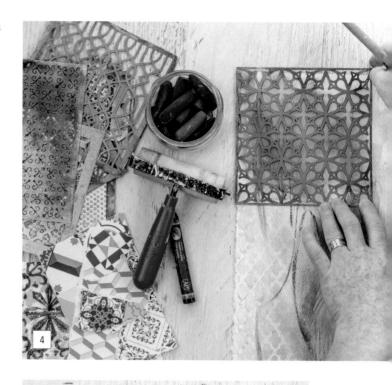

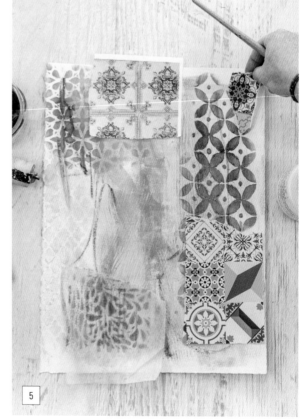

Tile Style
Tile design inspiration is easy to find in books or online. You can also find premade papers printed with tile designs to use in your work.

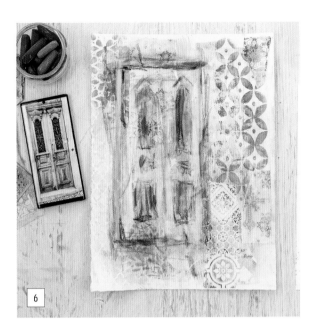

6

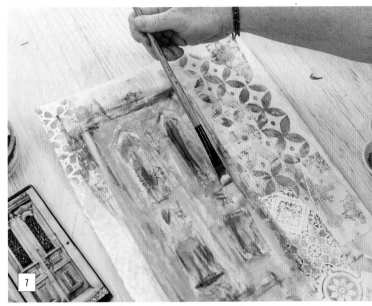

7

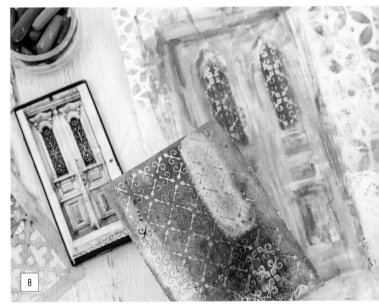

8

6 | Sketch a loose drawing of a door, using a water-soluble graphite stick. I used a reference image from a door I photographed in Lisbon; create one from your imagination or use a similar photo reference. Blend the graphite lines with water and gesso to give the sketch different value ranges and texture.

7 | Add a pop of color to the door. I used bright teal, which worked wonderfully next to the warm neutrals. The key to making this bright color stand out is to use restraint on the rest of the painting. As you play around with the possibilities, you will get familiar with the combinations you prefer.

I applied the teal paint sparingly, using a dab of paint with a dry brush and lightly running it over the surface. This captured the texture of the old door, and the color still popped. Remember, the image is not meant to be exact, only a dreamy interpretation of an architectural element.

8 | The original photo shows a beautiful grate over the window in the door. I mimicked this in my painting by using a stencil for the wrought-iron grate and sheer metallic gold paint. This is one of those touches that leaves me feeling very satisfied.

(continued)

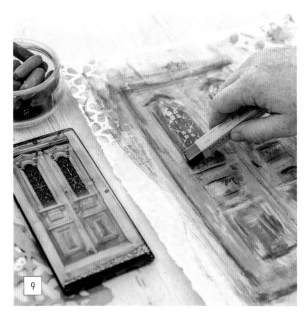

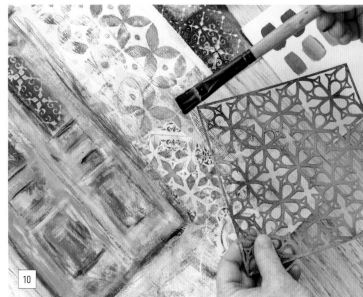

9 | It's still important to bring in a good value range to make the painting more dynamic. Use the graphite stick to bring out a few details in the door to enhance it.

10 | After looking over my composition, I decided to add a muted burnt orange stencil detail as a complement to the teal door. It makes the door pop and creates harmony in the work with the weight and texture next to the door, keeping it from "floating." That last touch may be just the thing you need to tie your piece together. The layers and texture really add that touch of old-world Portugal.

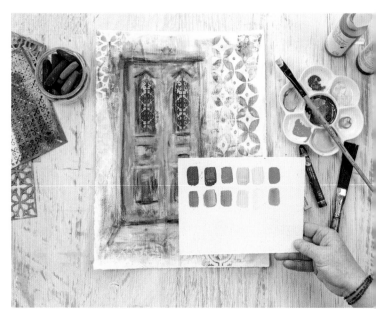

Keeping track of my color choices helps me make quick decisions the next time I'm stuck in a painting.

Guest Artist: LALY MILLE

"Dream Time"
24" × 24" (61 × 61 cm),
collage, acrylic, and inks
on stretched canvas
Website:
lalymille.com
Instagram:
@lalymille

No matter how well you might know color theory, there is something completely magical and inexplicable about color. The way it finds an echo deep within, touching our hearts and souls. The way it vibrates in the light, like the wings of a butterfly. Every color is a vibration, and, mysteriously, some of them feel completely in tune with our own.

This is what happened in this painting. It has all the colors and color combinations I love best, what I call my soul palette: translucent, jewel-like greens and turquoise; deep darks like Payne's gray and black; and touches of hot pink, peach, and rust, balanced with plenty of soft, opaque neutrals and white. Finding your soul palette comes with practice, but take the time to consciously gather and observe the things that move you and truly resonate with you (I love to create mood boards for this!). Knowing my personal palette not only gives me more confidence as an artist, but it also makes the creative process so much more enjoyable, soothing, and uplifting. Once the painting is done, I can only hope that the colors on the canvas convey this positive energy and resonate with someone else's soul.

6 TRICKY GREENS

PROJECT: DYNAMIC LANDSCAPE

The most difficult color to work with is green. Straight from the tube, some shades look like a Christmas explosion, while others are dull and lifeless. The best greens are the ones you mix yourself. In this lesson, we'll learn how to create the right mix of greens and how to create a great value range. As you mix various yellows and blues to create a range of greens, you'll be amazed at how many variations are possible. This experiment alone could take up a whole day.

In this lesson, you'll see how a green-centric painting compares with one that is balanced with other colors and more natural hues of green. When painting landscapes, many of my students are inclined to use a bright St. Patrick's Day green right out of the tube or mix a similar super-saturated color. To create a dynamic and interesting landscape, more variety is needed. That's why we're going to push the range of hues we use and include complementary colors.

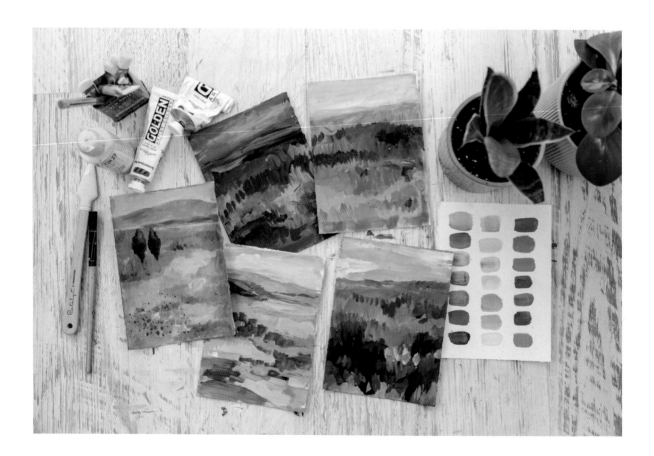

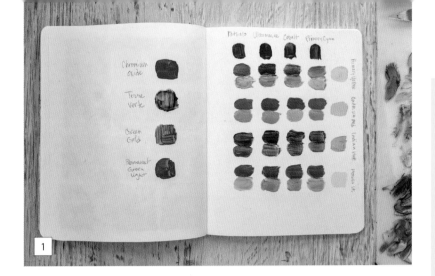

MATERIALS

- Acrylic paints
- Palette
- Paintbrushes
- Palette knife
- Stonehenge paper in white, approximately 5" × 7" (13 × 18 cm), torn into small pieces

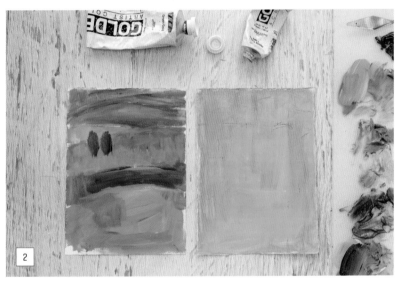

Note

In this lesson, we'll focus on creating a landscape with a wide range of colors. In each step photo, the super-green landscape on the left is an example I made to help you see what not to do. The landscape you'll paint with an array of colors will be more successful because variation is key.

1 | Choose four yellow shades and four blue shades of acrylic paint and mix them on a palette, using the techniques found in chapter 3 (see page 36). Create a chart, with the blue colors on one side and the yellow colors on the other, and swatch the different shades of green. I made two versions of each green—a darker one with more blue and a lighter one with more yellow. Experiment and add more or less of each color, as there is an infinite range of greens in between. You can add white to the mixes to create light greens, but these pastels may not be the shades you want for this project.

2 | For the dynamic landscape, create a ground with warm yellow paint. (For the super-green painting, I left the paper white to show how that affected its lack of depth.) The rich warmth from the yellow will make the final painting glow.

(continued)

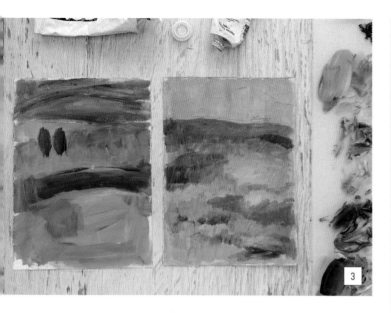

3 | Create a landscape composition from your imagination or use a reference, and sketch out a general configuration using the rule of thirds to guide you (for information on the rule of thirds, see page 100). Paint in thin layers of earthy green, covering only some areas of the land in your painting.

A Few Notes on Composition

- **CORNERS:** Make sure you don't have an object stuck in the corners of your work, and watch for lines or masses that move the eye off the corner of your painting.

- **DEAD WEIGHT:** If large shapes in your piece are hanging on the edge without any counter-balance, it will feel like the painting might tip over. If a tree or a house is at the edge of your view or in your inspiration photo, give it a spot in one of the areas marked by the rule of thirds (see page 100), or edit it out altogether.

- **SYMMETRICAL BALANCE:** Perfectly placed or evenly spaced objects make for a very dull painting.

- **EVEN MARK-MAKING:** Brushstrokes that are the same size and length make for a ho-hum painting. Some areas of your work need action and some need calm; provide room to breathe so viewers can rest their eyes.

- **CENTER MASS:** Keeping in mind the rule of thirds, we usually don't want to place objects or focal points in the center mass, in the middle of the horizontal or vertical lines of the artwork.

- **MIDRANGE VALUE:** Artists often struggle to figure out what's wrong with their composition, only to discover that their colors were in the same value range. Color is a major part of your toolbox, and pushing the range of color value is essential in creating a dynamic composition.

- When all else fails, fall back on my core principle: Variation is key. Keep your artwork interesting by varying all the elements!

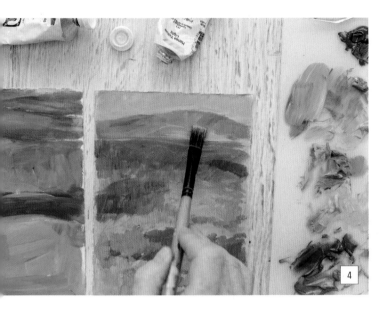

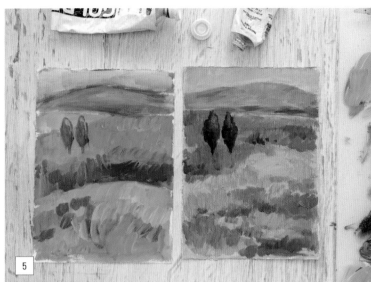

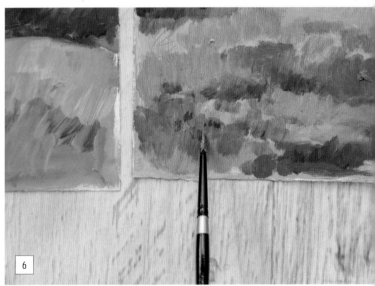

4 | Use a wide range of green hues to establish different characteristics of the landscape. If using a photo reference, pay attention to the details of the land, how the colors shift, and the nuance of the range of color that gives an impression of green. Even if you are using your imagination to create a painting, it's good to know basics about the land, like that the colors in the distance will be lighter and muted while your richest tones will be in the foreground. The light and dark values help move the eye throughout the painting.

5 | Add more layers of paint including some cooler greens and darker values. Build up more layers of paint with a variety of brushstrokes. Adding transparent layers of colors over the previous paint layers will begin to create some interesting effects and create depth in the landscape. Notice how much more interest these variations bring to the work compared with the super-green painting.

6 | As a final touch, add dots of color to the landscape to suggest flowers. My landscape was inspired by the southern French countryside where poppies grow everywhere, so I used red.

(continued)

7 | Looking at the super-green painting now, can you identify why it doesn't work as well as the dynamic painting? We may initially lean toward the saturated composition, but studying the difference between these examples and practicing painting using the concepts from this lesson will elevate your work. Try creating this project again, noticing the different results you achieve.

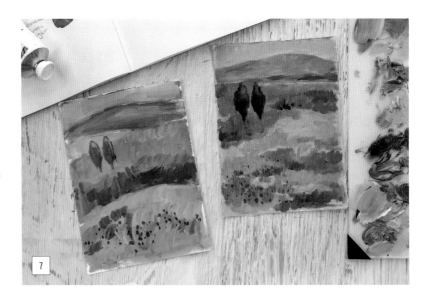

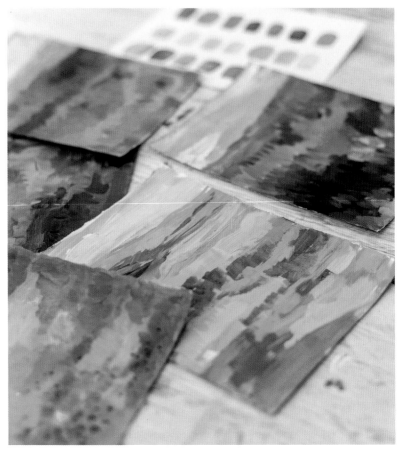

Try painting landscapes with different palettes for a variety of effects and moods.

Guest Artist: ANGE MILLER

"Altruistic Flow"
48" × 60" (122 × 152 cm),
acrylic and oil on canvas
Website:
www.angemillerart.com
Instagram:
@angemillerart

Although I tend to form color palettes intuitively, in hindsight I see recurring color themes in my artwork that seem to represent scenes in nature. For instance, this piece is ocean and sky. The deep blue forms the base of the color language, and every color I crave to place with it speaks of sunrise and sunset (pink, orange, lilac, and dusty neutrals) or the water's reflection of the sky. Metallic gold references the sparkling sun itself. Although my painting is abstract, and I have exaggerated some colors for contrasting effect, the color palette expresses an appreciation of naturally occurring color combinations.

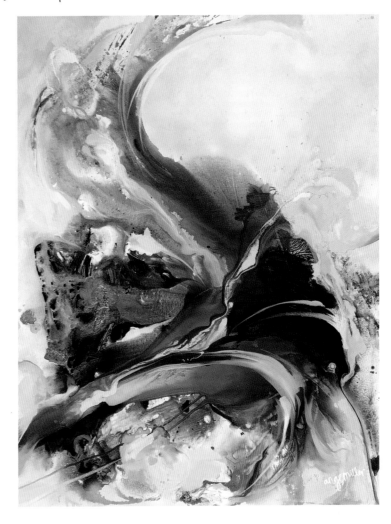

7 INFINITE BLUES

PROJECT: SMALL SEASCAPES

Color choices can be overwhelming, especially when it comes to blue. How do you choose the right shade? Blues can be warm or cool. If the color has red undertones, it's considered warm; if it has green undertones, it's considered cool. The blue you choose is entirely up to you, and I encourage you to play and experiment to discover what you like best.

This lesson will not only expose you to myriad blue hues, but it will also bolster your acrylic painting practice. If you don't have a million blues like I do, return to the color wheel warm-up lesson (see page 36) and mix a variety of blues using the modern primaries. Once you have a nice selection, begin playing with paint and create these lovely small seascapes.

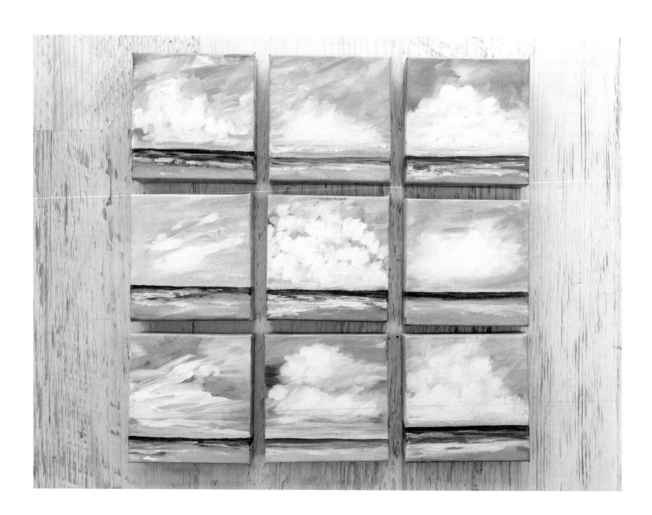

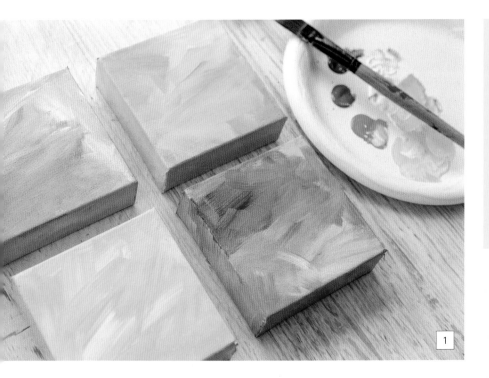

- Small square stretched canvases (I used 4" × 4" [10 × 10 cm] canvases)
- Paintbrushes
- Acrylic paint, including heavy-body white
- Palette

1 | For this lesson, we'll be working on multiple mini canvases at the same time; I worked on four at once. Doing this offers a chance to experiment with more shades of blue. Painting multiple canvases helps establish a cohesive series, even if different color palettes are used. I also find that while working on several canvases, one idea leads to another, which I can try instantly on another piece.

Begin each painting with a different acrylic paint ground. A ground is a first layer of color on a canvas that influences the overall tone of the painting. I usually like to use warm colors such as pink, yellow, orange, or red mixed with white to create contrast with the blue added later. To give the surface a painterly look, don't completely blend all the paint, but allow for variation in the marks. Allow to dry.

Take It to the Edge
Don't forget to paint the edges of the canvases; this makes the pieces look complete and ready to present.

(continued)

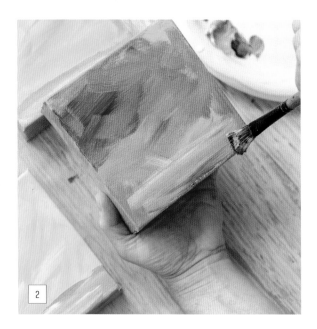

2 | Create the sand for the seascape. I used my favorite combination of paint colors: Titan buff, Van Dyke brown, and warm gray. To achieve the striations in the paint that mimic sand, dip a paintbrush in two or more colors of paint and brush them onto the canvas. Paint about one-quarter of the way up from the bottom, and do not blend the colors completely.

3 | For the sea and sky, we will mostly use one variation of blue, plus white. Heavy-body white paint will allow you to create clouds with a bit of texture.

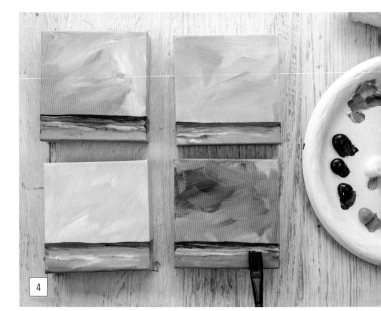

4 | To create the ocean, keep two things in mind: Water is usually darker at the horizon, and the horizon line is always straight. Select a darker blue, such as phthalo or Prussian blue, and create a straight line for the water about one-third of the way up on the canvas. While the blue paint is still wet, mix a dab of white into the blue and slightly cover the sand, allowing it to peek out from the surf. Don't forget to paint the edges of the canvas. Allow to dry.

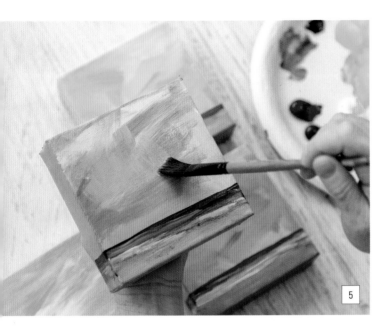

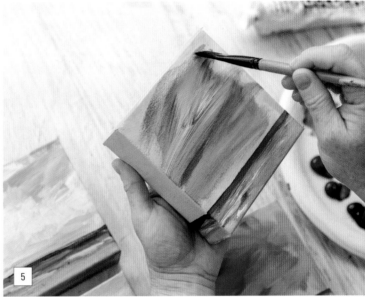

5 | Use the blue already on your brush to create the sky. Use the marks and brushstrokes of the bright ground color to inspire your next brushstrokes.

6 | Mix in more white with the blue, and remember that the sky is usually much lighter at the horizon. Go with the flow, but don't overbrush and lose the marks you've created. The unblended marks represent the clouds. Also, be mindful of not covering up the entire ground color; this will give your painting a sunset glow.

(continued)

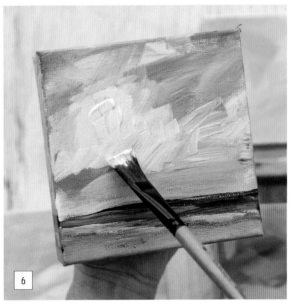

7 | At this stage, I like to allow my intuition to take over while continuing to paint the sky. I let the previous layers tell me where to put the next marks. Does a brushstroke look like a cloud or a windswept sky? Make sure you let the marks be. Don't overthink this step or you may overblend the sky and cover up the bright pops of yellow or pink underneath.

8 | Creating waves and ocean breaks tends to use very similar methods as painting the clouds. Using a dry brush and a little white paint, drag the brush across the edge of the water where it hits the sand. Allow the brush to skip on the surface and make irregular marks. An abstract seascape should look believable but not completely realistic, so be mindful of the horizon line, shading, shadows, and color details.

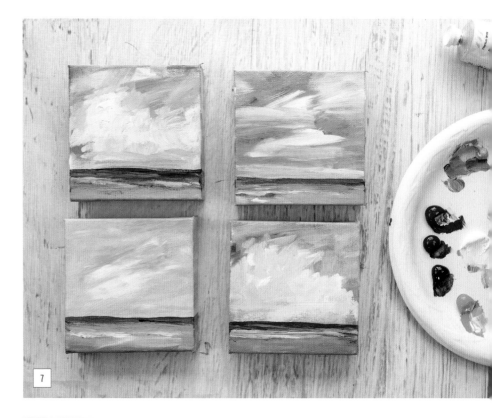

Lighten Up
Since acrylic paint dries darker, make sure to add enough white to your seascape so it doesn't look like a nightscape. Always go several shades lighter than you think you need to paint a sky.

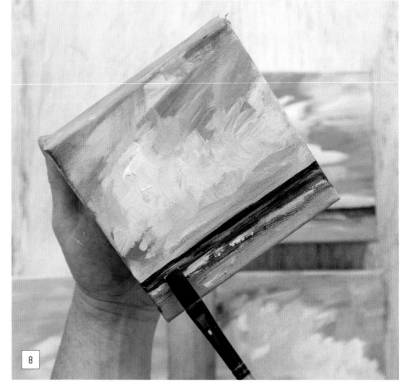

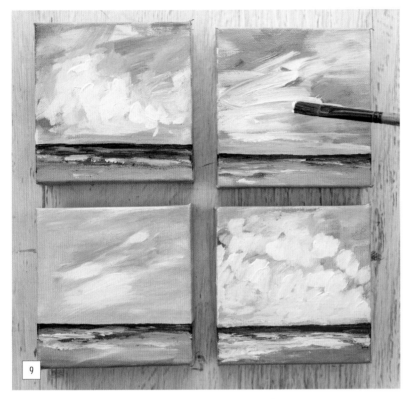

9 | Carefully match up the sides of the canvas with the top, and finish up the details. At this phase, I focus on cloud building, layering little dabs of heavy-body white paint onto the peaks of the clouds to give them more dimension. Remember: You're painting clouds, not little puffy sheep!

10 | There are a million different variations of clouds and skies. Study them, take pictures, practice making mini seascapes using various background colors and shades of blue, and you will soon be an expert sea and cloud painter. These are abstract and intuitive, so have fun!

Some of My Favorite Shades of Blue

Ultramarine	Anthraquinone	Cerulean	Cobalt
Phthalo	Payne's gray	Manganese	Ultramarine light
Prussian	Turquoise	Primary cyan	Teal

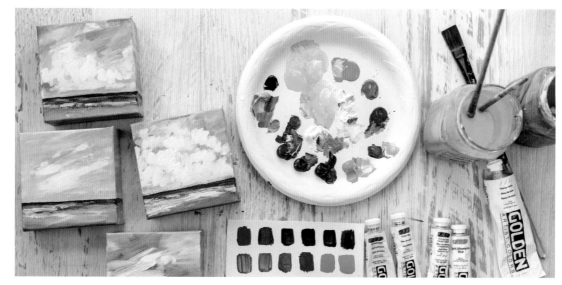

Guest Artist: REGINA LORD

"Raven Sunrise"
8" × 10" (20 × 25 cm),
acrylic paint on canvas
Instagram:
@regina_creativekismet

Color is one of the most exciting elements of painting. It stirs emotion, creates energy, and adds an element of aliveness. When I paint, I am more interested in creating a mood or feeling, so I ask myself: What do I want to express today, and how? My goal is always to convey happiness, joy, and wonder by tweaking what "is" into something more bold and magical. It brings me peace and gives me hope to put brightness and color into the world, especially in times of darkness. This is what I want to pass on to the viewer. I begin by laying down the first layer of color—any color—just to cover the canvas and get into the flow and movement of painting. The subjects I always go for are usually inspired by nature, such as animals, birds, and flowers from the southwestern desert where I live. I especially enjoy playing with complementary colors that bring tension and vitality into the painting, building layer upon layer, and allowing the colors to increase in energy and vibrancy. I only paint what I truly love so that each stroke of paint carries that same love and passion. This all allows the painting to come alive with everything I've put into it.

8 TAMING THE WILD ORANGE

PROJECT: ABSTRACT FLORALS

Orange is an inherently bright color and can overpower a painting quickly. What if we tamed it a little with complementary colors, or other shades of orange, or turned it into coral? Once you learn to incorporate orange and make it less dominating, it might become your new favorite go-to color. Shades of orange make their way into about half of my work.

In this exercise, we'll let loose and create an abstract floral painting. Orange will be the focal color, and we'll explore how its many variations can be used together. You'll discover how to reel in the color orange, use it thoughtfully, and still let it shine as the star color of your painting.

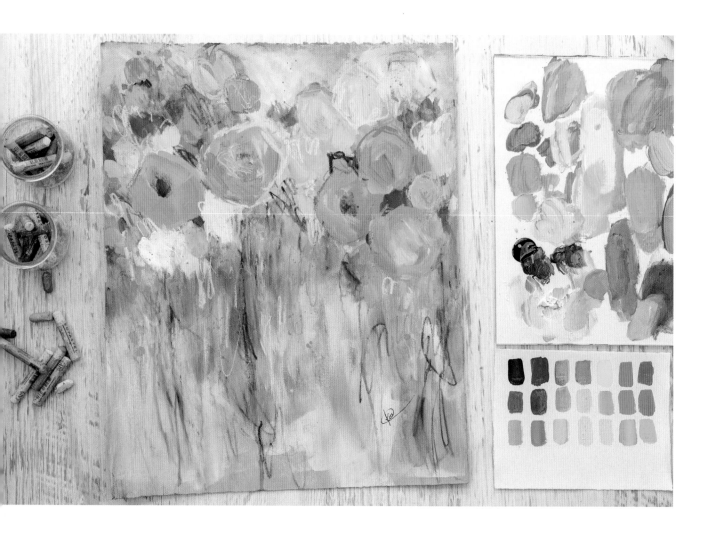

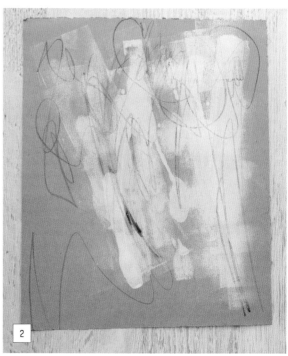

MATERIALS

- Stonehenge paper in kraft (I used a 11" × 15" [28 × 38 cm] piece)
- Graphite stick
- Brayer
- White gesso
- Acrylic paint
- Spray bottle with water
- Oil pastels

1 | Working on the paper, start with a scribble, using a graphite stick. This breaks up the blank page and gets the juices flowing.

2 | Use a brayer to paint a layer of white gesso over the scribbles. This gives the paper strength and a substantial layer of bright white that will contrast with subsequent layers of color. I like letting some of the paper show through, especially around the edges. This gives the painting more interest through the textures that are revealed.

(continued)

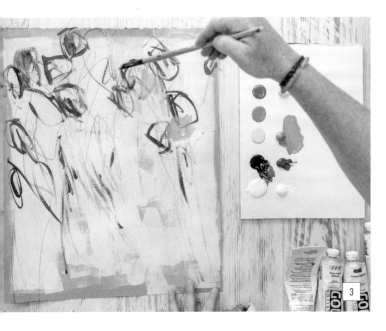

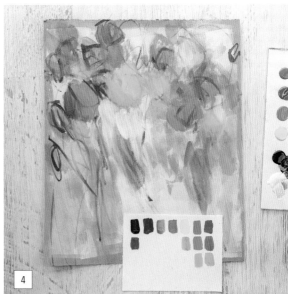

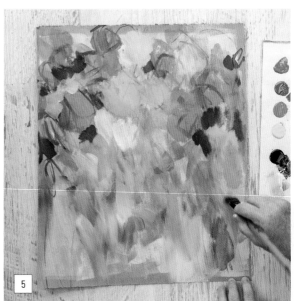

3 | Lay the groundwork for your composition by creating intuitive lines where you imagine your floral arrangement will be. I used Van Dyke brown, which will create contrast as the layers build. Remember to vary the size and shape of the florals. If they are all the same size, they will be more like balloons. Nature is organic and irregular, so the shapes should be as well.

4 | To build a palette of subtle oranges, mix several shades and hues of orange to create lush peaches, corals, and poppy colors. I used primary magenta, primary yellow, pyrrole orange, and white to create a range of options. Use these shades to block in abstract floral shapes, adding the colors to the background as well.

5 | Add shades of green and blue around and below the blossoms to complement the floral focal point. A small amount of cerulean blue makes the orange flowers pop, and a mix of greens in abstract gestures begins to pull the painting together.

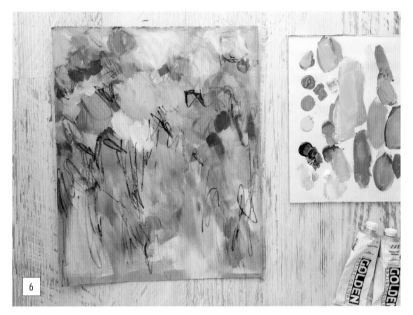

6 | Working in layers to create depth, continue to add paint, marks, and interest to the piece. I scribbled more marks with the graphite stick and created a complementary light aqua background.

7 | Stand the piece upright and spray a light mist of water over a layer of wet paint, allowing the paint and graphite marks to drip and spread in unexpected ways.

(continued)

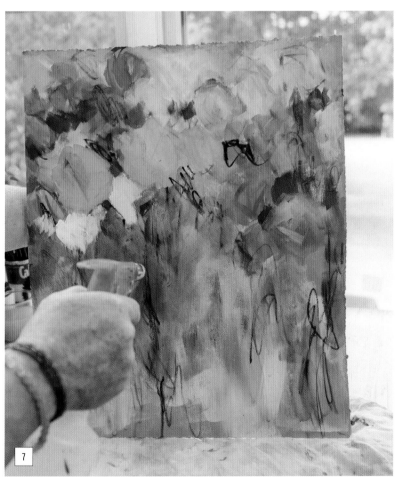

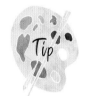

Turn on the Waterworks

When I come to a block in my work and I feel it needs a bit of drama, I use this misting technique. The drips and surprises inform my next steps as I use the paint flow to help me decide what to add afterward.

8 | When the composition seems to be coming together and the balance of color and interest has emerged successfully, add the last layers of paint to shape and emphasize a few of the flowers. Use brushstrokes to suggest petals and centers. Leave some flowers with less detail.

9 | Are the flowers orange enough? As a final touch, add an extra pop with oil pastels. The saturated color leaves beautiful lines and marks that complete the work and make it stand out.

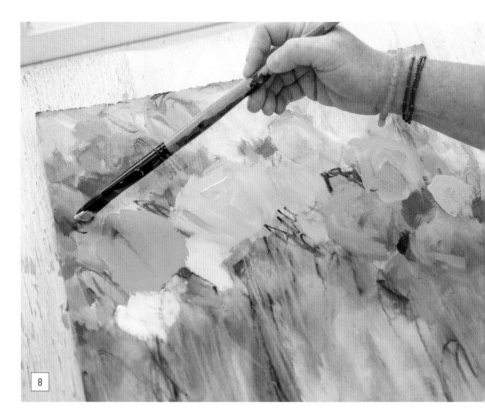

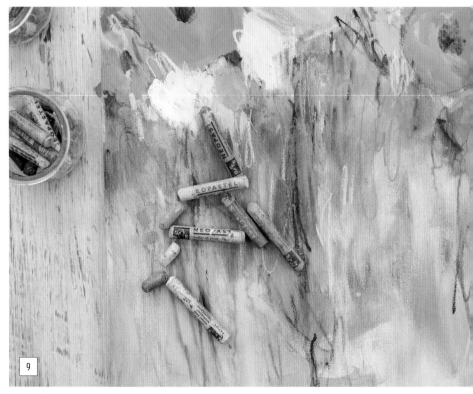

Guest Artist: BECCA BASTIAN LEE

"Titian Gold"
11" × 14" (28 × 36 cm),
acrylic on paper
Website:
beccabastianlee.com
Instagram:
@beccabastianlee

In my figurative and illustrative work, I use color in a way that's not quite realistic or true to life. If you took a photograph of my friend's brown hair, for example, there would be no way it would have deep purple shadows. But those are the colors I see when I look deeper, past what is there.

In this piece, I used a technique I've developed for acrylic painting: I laid down a ground of cadmium red light, mixed with white. This infused the painting with warmth. Then, I painted a quick outline of features with fluid magenta paint. I layered in the skin tones, using cool colors for highlights and letting the warmth of the background come through the rest. I allowed the lines to show a bit, touching them up where needed. I left the rest of the painting unfinished to give the impression of a quick studio study portrait.

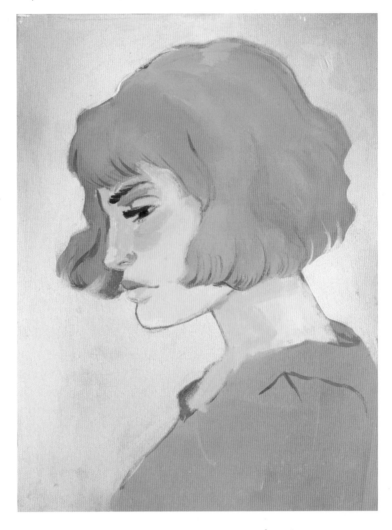

I have a thing for redheads (I'm a fake one!), so I chose a bright Titian Orange for the hair. I chose a combination of complementary colors—pale aqua and bright oranges—to achieve a high-contrast look while keeping the overall painting flat and within a medium-value range.

9 ROYAL PURPLE

PROJECT: MIXED MEDIA LANDSCAPE

Purple is a popular color that's been used by royalty throughout history because of its rarity. But we don't need a pure hue when red and blue make purple. The key to mixing this shade is knowing how to use a hue of red and a hue of blue to produce the shade of purple you want. Artists become more confident when they're able to choose the right colors to mix the perfect purples.

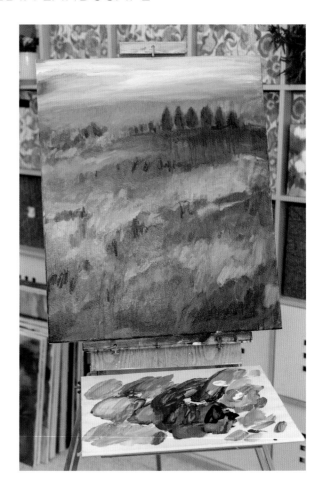

While we usually think of landscapes, grass, and trees as always green, the truth is that with the right light or squint of an eye you'll see all the hues of the rainbow. Push what is expected and reimagine what is possible when you use color for landscape. Purple for the shadows on a cool autumn day? Why not?

Let's identify which tubes will make the most intense and unmuted purples. To create a mixed media abstract landscape, we'll mix different reds and blues to produce a variety of purple shades. The purple you use is a matter of preference. I gravitate toward redder violets and muted plum colors, but you may favor vibrant bluish-purples. Knowing how to make these colors is key. We'll also discover which paints straight out of the tube make the most vibrant purples and which offer earthy plums, red-violet shades, and bluish-purples.

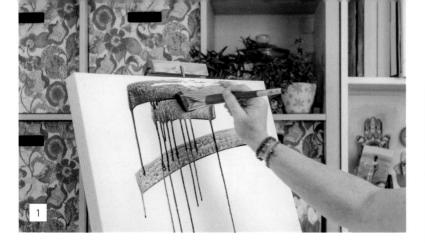

MATERIALS

- Gallery-wrapped canvas (I used a 18" × 24" [46 × 61 cm] canvas). Note: I don't work on gallery-wrapped canvases very often, but I like using them when I'm not adding collage or a lot of mark-making.

- Paintbrushes

- White gesso

- Acrylic paints

- Water

- Reference photos (optional)

- Spray bottle with water

- Oil sticks or oil pastels

1 | Prep the canvas with a layer of white gesso. Use a thinned-down brown paint to create the ground. Use a ratio of 70:30 of water to paint. The mixture should be light and fluid as it covers the entire surface. Stand the canvas up and allow the paint to drip and create interesting marks. This earthy tone will be a perfect complement to the purples we'll use for the landscape. Allow the paint to dry.

2 | Mix a range of purples using three shades of red and three shades of blue. Try using combinations of primary magenta and primary cyan, quinacridone magenta and phthalo blue, as well as ultramarine blue and cadmium red. Which make the brightest hues, and which make the earthiest? Which do you prefer?

(continued)

Tip

Finding Inspiration

Sometimes I use reference photos for inspiration, but most often I paint from muscle memory after having studied the land and practiced painting its forms for so long. Use images you love to inspire you and save them in a digital file on your computer or use Pinterest. Using images as a jumping-off point without making exact copies is a great way to charge your creative muses.

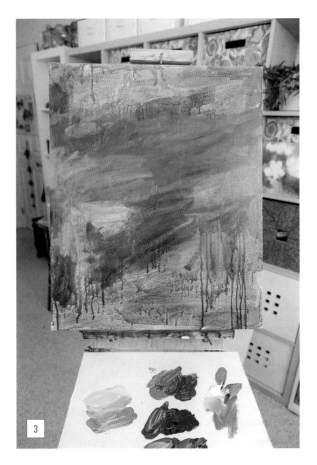

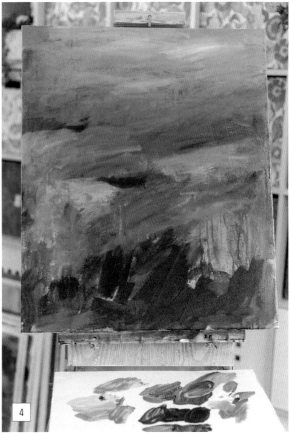

3 | Paint washes across the canvas with the various shades of purple you created. Work from intuition or use reference photos to create your composition, thinking about the design and representation of the landscape. (Using images as a jumping-off point without copying the original is a great way to charge your creative muscles.) Be mindful of the rule of thirds to create a successful design.

4 | Block in other colors, being mindful of values. Use a light blue at the top for the sky. Light green keeps the painting grounded in reality. Adding deep purple-blue at the base creates a striking contrast. Make sure that purple remains as the dominant color on the canvas and be sure to leave some of the background showing.

The Rule of Thirds

The rule of thirds is an imaginary process where you divide your canvas into thirds by picturing two evenly spaced horizontal lines and two evenly spaced vertical lines. This gives you nine sections and four intersections. When the most important parts of your painting are placed at these intersecting points, a more natural painting will evolve.

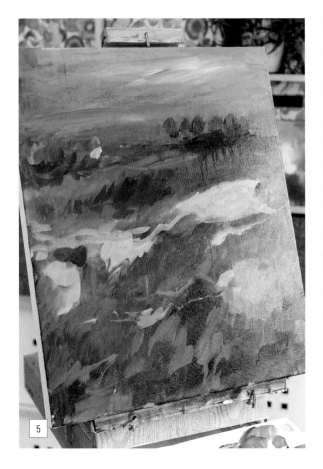

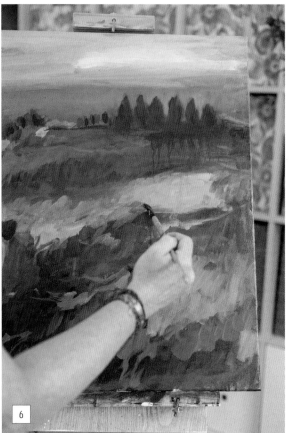

5 | Bring in yellow as a complement to the shades of purple. In order to create variation and to mimic the different elevations and vegetation of the land, paint with different types of brushstrokes. This also helps move the viewer's eye around the piece.

6 | Add landscape details such as trees. Add marks to represent changes in the land, such as hills and valleys. The idea is to give an impression or a suggestion, not to create something exactly as it would be seen in nature. Use a dab or two of paint to mimic what you want to see.

(continued)

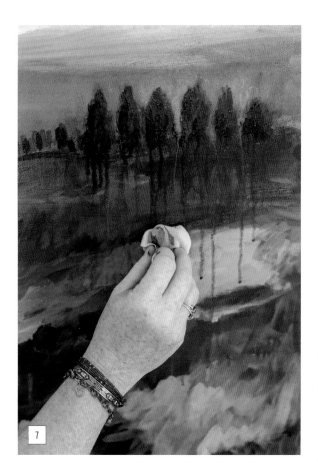

7

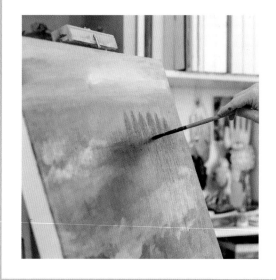

That Awkward Phase

Sometimes, a piece will go through what a friend of mine calls the awkward teenage phase—full of potential and, at the same time, full of doubt. I call it the ugly phase and may start to doubt myself. This has happened so many times that I now understand I need to see the painting through its adolescence. You have two options when this happens: Push through if possible or take a break and come back later with fresh eyes.

7 | If your details begin to look too contrived, spray the wet paint with water and watch it drip and run. This frees the design and lets serendipity happen. If the drips overwhelm the painting, wipe them up before they dry. It can be satisfying to see these unpredictable new formations in your work.

From this point on, a lot of back-and-forth happens with a painting, a balance of calling on your foundation skills and following your intuition. The most important thing to remember as you work through the muck is that variation is key.

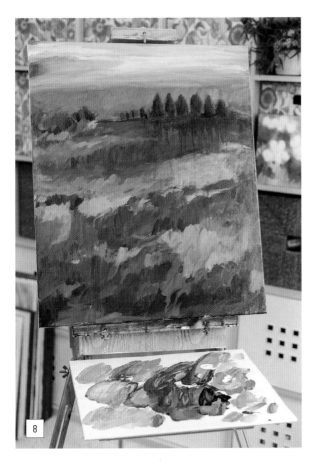

8

9

8 | After working out the composition, being mindful of value, mark-making, where your eye leads you, and the overall placement of color, let the painting sit. Take a couple of photos of the piece and walk away for an hour or a day, giving yourself a moment to breathe. Then come back to it with fresh eyes. You'll know what to adjust and fix.

9 | Add final touches with oil sticks or oil pastels where colors converge or where the composition needs to be strengthened. I love the sketchy marks and beautiful texture they create on the surface of the canvas. I often only use like color with like color: green over green or a similar hue of purple over purple. This gives the painting a subtle shift but makes an impact in the overall richness. Alternatively, add any last details with acrylic paint marks.

Tip

Using Oil Sticks
Oil sticks dry completely and are better suited for surfaces that will not be framed behind glass. Because they are oil-based and not water-based, be sure to use them as a last layer.

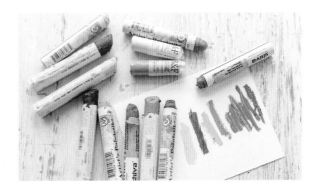

10

A THIMBLE OF RED

PROJECT: ABSTRACT GARDEN

Henri Matisse said, "A thimbleful of red is redder than a bucketful." Red is a powerful color, and when used in the right amount, it can make a great impression in your painting. Too much, though, can be off-putting. After practicing with all the many layers of red in this lesson, artists should be able to achieve the look of red without needing pure red.

The magic of this playful project is in staying loose and free and scribbly with the layers, producing results that are fresh and abstract. I've had to train myself to not make everything smooth and detailed so that my artwork can be more abstract and interesting.

Remember that varying the values, marks, and colors is key. You'll learn how to balance earthy greens with many variations of orange, pink, coral, and other warm tones to represent the feeling of red.

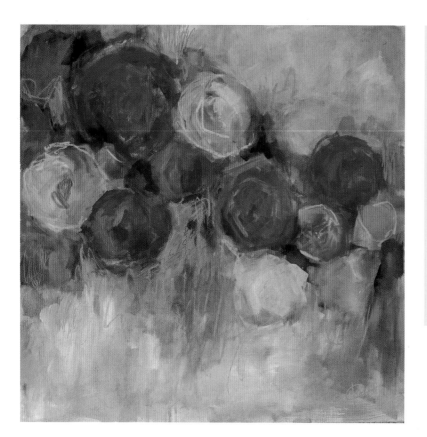

MATERIALS

- Cradled wood board (I used a 24" × 24" [61 × 61 cm] board)
- Brayer
- White gesso
- Graphite stick
- Paintbrushes
- Acrylic paint
- Oil pastels
- Spray fixative

1 | Prep the board as discussed on page 21. Using a brayer, apply a layer of white gesso, creating a rough but evenly covered surface that will accommodate the subsequent layers of paint and marks.

2 | Using a graphite stick, scribble over the gesso. Why scribble if you're going to eventually cover up the marks? This technique will loosen you up and allow you to face the surface without fear. So scribble away and be free, my friends!

3 | Let those scribbles serve as a guide to your composition to help you plan out your floral work and where to put your organic shapes. With acrylic paint, add an underlayer, or ground, this time much more sporadically. Since the overall tone of your final work will be mostly reds and pinks, begin with some cool greens and yellows. These complementary colors will peek through and influence the painting as you go.

(continued)

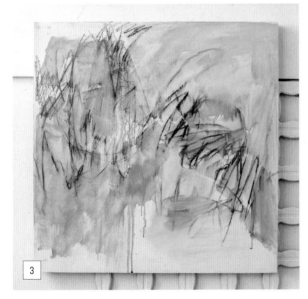

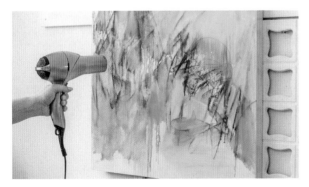

Quick Dry
Make sure each paint layer is dry before adding another or you will make mud. Use a hair dryer to hasten drying, but be careful not to heat up the paint.

4 | Using dark, rich, red shades, block in the flowers with loose, gestural marks. Consider the composition seriously at this point. Vary the shapes and sizes of the flowers, and position them in a way that prevents creating a center mass cluster. The rule of thirds can help you place them in the top or bottom third of the painting, avoiding the middle.

5 | Fill in the area around the flowers with muted, earthy green and brown hues to represent the thick of the growth in a garden. Rather than looking at a reference image, imagine how the garden would feel, and use your foundation skills to guide you in creating the elements. Ask yourself if the composition looks right, and keep the rule of variation in mind.

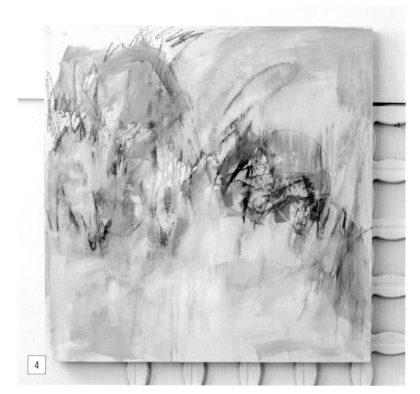

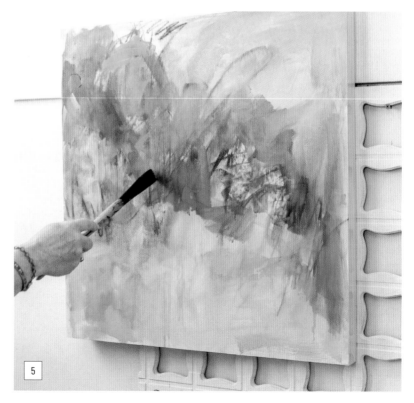

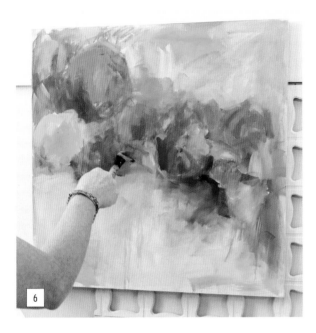

6 | Mix shades of peach and pink for the flowers, using a complementary shade of green to mute the pinks a bit. Decide where you want to add more flowers, thinking about where your eye wanders and where it gets stuck. Make sure you're using different shapes, sizes, and spacing for the blooms. Avoid the common mistake of creating a straight line of red balls across the top of the canvas.

7 | This lesson is all about the red family as the main attraction, so push the underlayer of green hues to the back and layer more corals and pinks to the entire surface. You can still allow the green underlayer to show through in spots.

(continued)

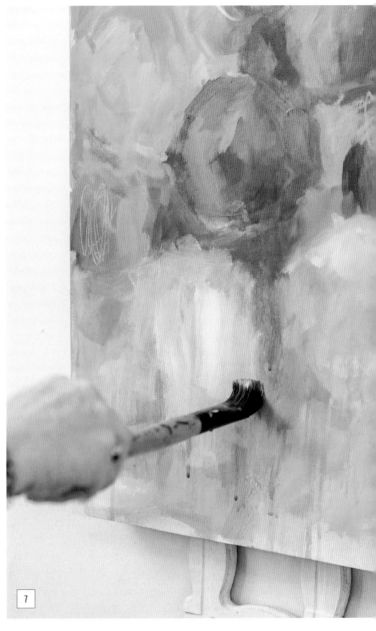

8 | Continue to work freely by holding the paintbrush at the end and making light gestural marks using a variation of different reds, pinks, and coral hues. Tightening up and focusing on details will change the feeling of your painting. I prefer my work to be abstract, so I recommend stopping before you go too far.

9 | The last painting step is to build up the flowers with a few more thick brushstrokes. Try to make a mark and leave it; let a dab be a petal, a stroke be a stem, or a swish be a leaf.

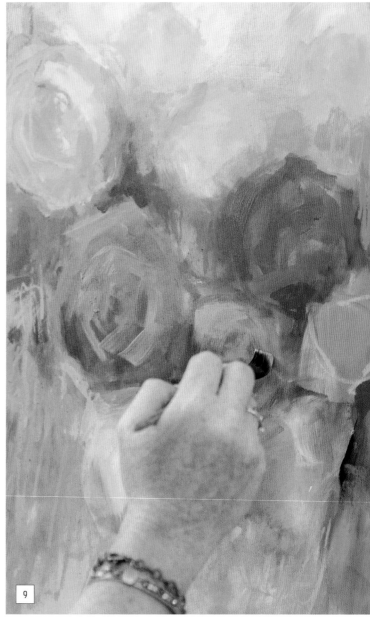

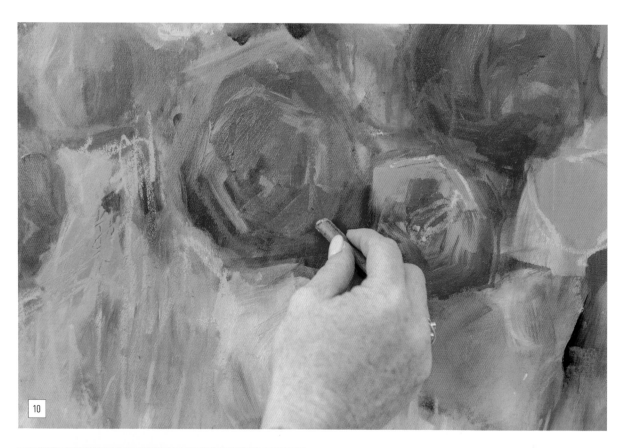

10 | Add a pop of saturated color by creating line work with red or peach oil pastels, bringing out the shapes of the flowers. As a fun complement, make a few thoughtful marks with teal green pastel. Finish with a spray fixative and spray varnish, which will cure the oil pastels.

I may use a limited selection of colors, but it still makes a big impact.

11 BLACK AS A COLOR

PROJECT: MIXED MEDIA FLORALS

The Impressionists often eschewed using black in their paintings. They used color in new ways for fresh interpretations of nature and life. Dark hues were made by mixing various colors. I love this approach and most often will follow suit in my artwork by creating black or dark hues out of pure color. But every now and then, when I feel wild, I use black to make a bold statement.

Don't be afraid to use black! It's the perfect color for creating drama in your artwork if used judiciously. In this lesson, black plays a minor role as it gets pushed to the back, allowing the focal color to create a bigger impact. You'll learn how to mix black with primaries to create a new and exciting color palette and how to work from darkest shades to lightest.

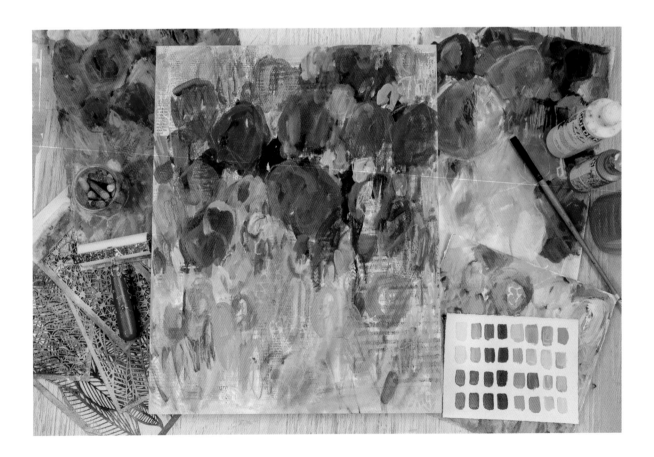

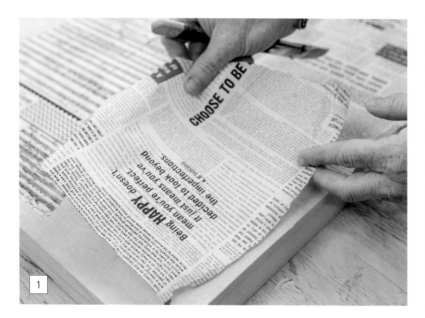

MATERIALS

- Cradled wood board
(I used a 18" × 20"
[46 × 51 cm] board)

- Collage papers with text,
such as book pages or
newsprint

- Paintbrush

- Heavy-body gel medium

- Brayer

- White gesso

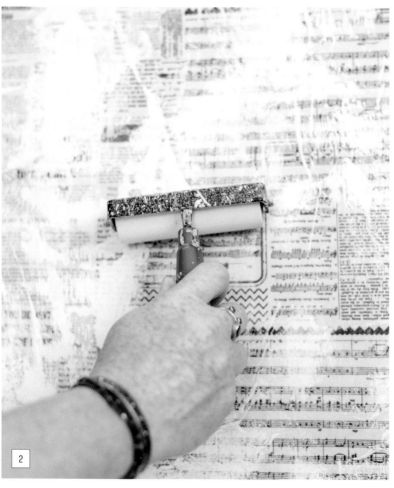

1 | Create a background by adhering pieces of text or newsprint to the board with heavy gel matte medium, covering the entire surface. Allow the gel medium to dry.

2 | Using a brayer, tone down the collage papers by covering them with a light layer of white gesso. Don't completely cover the text; a light pass with the brayer will soften the text. Allow to dry.

(continued)

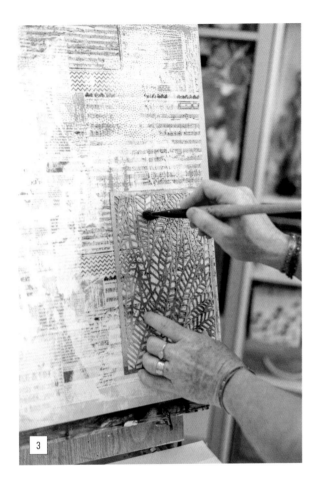

3

3

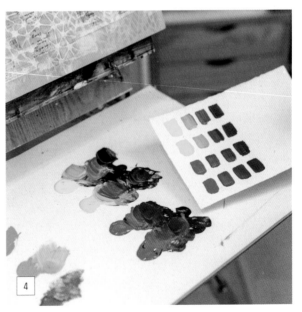

4

3 | Using a dry brush with a small amount of paint, stencil over the previous layer in areas. I used warm yellow and teal, which will contrast nicely with the flowers when used sparingly. Any designs or alternate methods, such as stamping or mark-making, will work for this project. Play bold!

4 | While the layers dry, create a limited color palette using black (as a substitute for blue), yellow, and red, plus white (for instructions on creating color mixes, see page 36). Substituting black for blue will produce the most gorgeous purples and greens. When white is added, the colors become more muted.

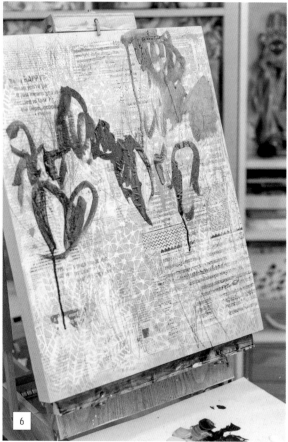

5 | Add another layer by marking up the surface with graphite, colored pencils, chalk pastels, or any other water-soluble medium. This activates the space.

6 | Using black or one of the darkest mixes, map out a floral composition. Use a photo reference or your intuition while still remembering my one rule: Variation is key. Work with the darkest values first to define your work and to create depth in the florals. Place your focal point in the top or bottom of the board.

(continued)

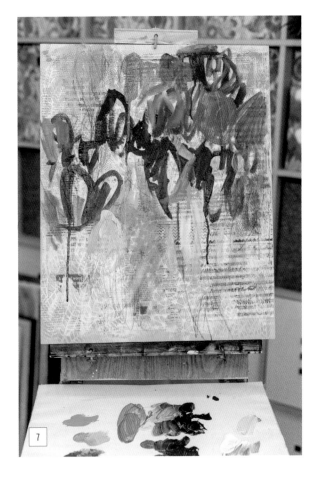

7 | Continue creating a variety of flower-like shapes, layering them on top of one another and varying the size and placement. Use the color mixes from step 4, which are harmonious hues. Allow some of the colors to dominate in different areas of the painting, creating tension and excitement.

8 | While the majority of the richest colors are at the top of the painting, we can still bring attention to the rest of the work with greens and soft peaches and violets from our color mixing earlier to pull viewers deeper into the painting without overwhelming them.

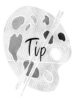

Capturing Florals

When creating florals, include some that go off the edge or end just at the edge of the substrate—each flower doesn't have to be fully contained within the space. Vary the sizes of the blooms, and avoid making them look like cinnamon rolls. Create organic shapes that represent real flowers, instead of painting a simple swirl.

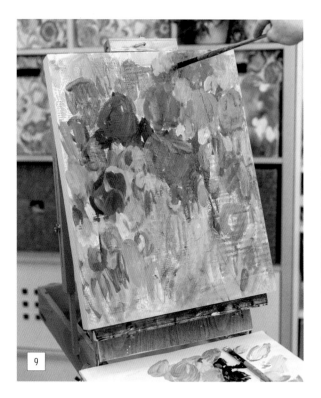

9

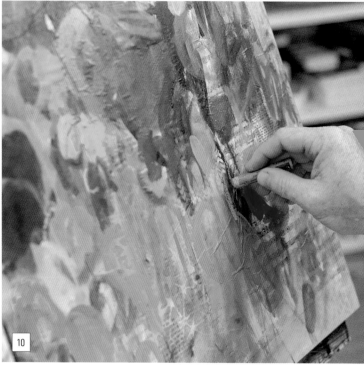

10

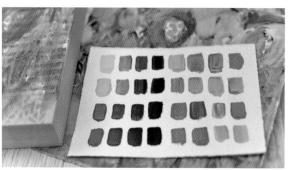

Who would have thought that black with red and yellow plus white could mix up such beautiful greens and purples?

9 | This is the part of the process where we get to dance with the work. A little color here and a little color there. Take away some and add some more. Throw in a tiny pop of teal as a contrast to the muted colors. Remember that it's important to love the process more than the results because it's the experience that matters most.

The best advice I can give you for creating abstract flowers is to stop before the piece is overworked. If you're not sure you've gone far enough, hold the painting up to a mirror or take a photo of it. My goal in a work like this is to make gestures and marks that feel free and undefined yet create enough of a hint as to what the subject is meant to be.

10 | Add oil pastel touches of pure color to define the florals or add pops of color and texture to make the work more interesting. In contrast to the more muted tones of the palette, the pastel marks finish the work nicely.

12 YELLOW ON TOP

PROJECT: MIXED MEDIA ABSTRACT BOTANICAL

Yellow is the lightest color on the value chart and can be used to create instant warmth or bring a lightness to your work. Playful and undeniably happy, yellow is always at the top of my color wheel to remind me of its place in my artwork. When mixing colors, use yellow instead of white to get lighter, more vibrant shades of green and orange. White will only create washed-out pastels.

Let's get wild with our biggest project. This is a great opportunity to try out any of the mixed media techniques or ideas that we've covered, and we'll see what happens when we bring it all together into one big yellow phenomenon. Don't hesitate to make it your own!

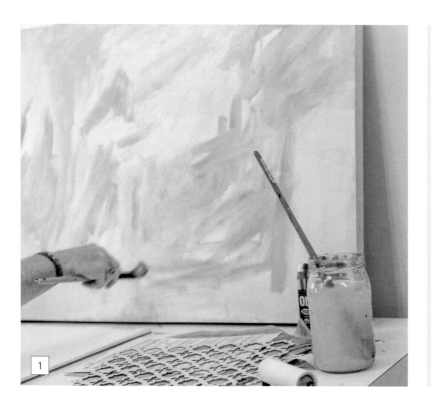

MATERIALS

- Cradled wood board or a large sheet of art paper (I used a 24" × 36" [61 × 91 cm] board)
- Acrylic paints
- ArtGraf Artist Water Soluble Tailors Chalk in sienna
- Collage papers
- Heavy gel matte medium (or preferred adhesive)
- Artist-grade acrylic-based spray paint
- Texture tools, such as a foam roller, silicone brush or tool, or a plastic key or gift card

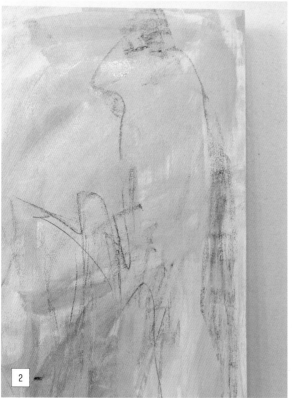

1 | Gather your materials, prep the surface of your board or paper (see page 21), and let's experiment with all of our mixed media ideas. Start by choosing a color palette. In this project, I'm using paint out of the tube and not mixing much. The focus will be on using layers of yellow from here on out—it's our dominant color, allowing us to emphasize lightness. Paint the surface first with neutrals—such as Van Dyke brown, a soft coral pink, and a touch of cool mint green—making random intuitive brushstrokes. These colors will eventually play a lesser role, but I am starting with them to create contrast and dimension before the next layers are added.

2 | Add marks with an ArtGraf Artist Water Soluble Tailors Chalk in sienna. I like being able to get a thin line or larger shading marks with the same tool. If you don't have ArtGraf, you can use any mark-making tool, such as graphite, colored pencils, or chalk pastel.

(continued)

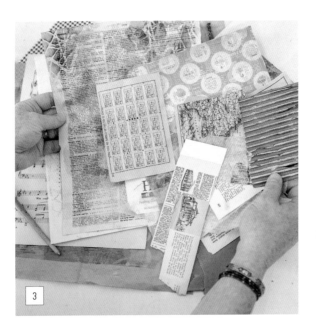

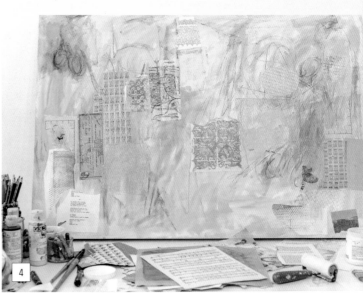

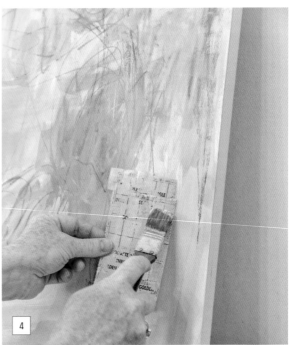

3 | Carefully select collage papers and ephemera from your stash that go with the color story you chose for this painting. I selected papers featuring yellows, warm pinks, and peach and brown tones. But, a touch of complementary muted blues or greens is fun to add along the way.

4 | Think through the placement of the papers, since it's as much a part of your composition as the paint—this shouldn't be a random act. What marks are already directing your call to action? Where does it make sense to adhere these elements, and where will parts of them show through the final layers of this painting? Use heavy gel matte medium, or your preferred adhesive, to adhere the papers. Allow to dry.

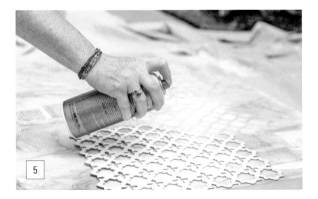

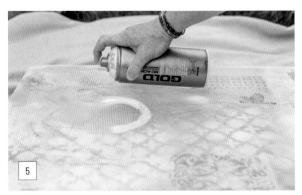

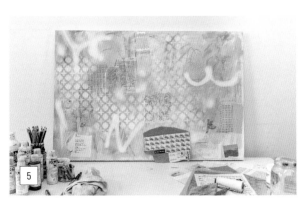

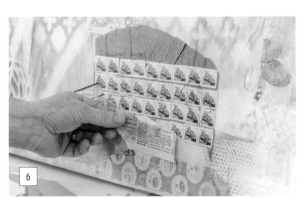

5 | Make your mark, be playful, and experiment with the spray paint on the board or paper. At this point, it's all just building up and the spray paint marks are part of the intuitive process. Try using stencils or found objects to spray over or through; try spraying from a distance or up close to create; and make marks that are interesting to you, the artist. I chose white and yellow, but this project can be done with any color range. Artist-grade acrylic-based spray paint is easy to use and less toxic than regular hardware store spray paint, but it's wise to take your work outdoors when spraying. Leave the work outside until it's fully dry.

6 | Add another layer of collage to make it a stand-out element of the piece. Be thoughtful, using hues that are within the same color scheme. Don't go overboard with the additional elements, which could cover up the previous layers—we want them to show through.

(continued)

Spray Paint Tips

When using spray paint with a stencil, always spray from at least 1 foot (30 cm) away to produce a cloudy mist. For creating sharper lines and your own designs, get closer to the surface, about 2 inches (5 cm) away, to better control the spray.

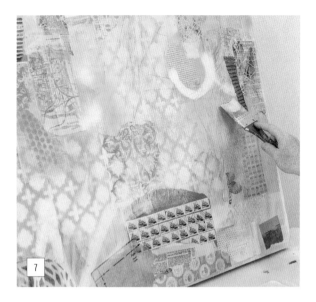

7

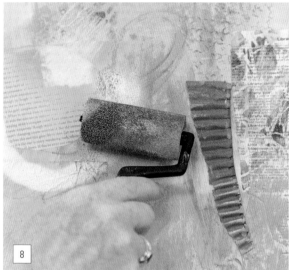

8

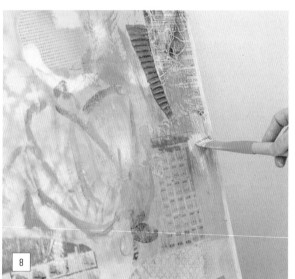

8

7 | Add a touch of yellow and white acrylic paint to keep the piece light and not obscure the layers underneath. This will also push back some of the recently added collage elements. This may be your awkward-teenager/dancing-around-the-canvas phase. Keep pushing through until the elements start to click.

8 | Texture can be one of the most interesting things about making art, so try out some different tools to achieve that effect, such as a foam roller, a silicone texture tool from Princeton Catalyst, a plastic gift or key card, and anything else you can get your hands on to experiment with the paint. When trying to achieve balance among all the elements, texture is one thing that can pull them all together. You'll intuitively know when the texture is right. In this case, the texture is just part of the play to create the layers. Too much and you cover everything up; not enough and it's not noticeable. The repetition of the same type of texture in similar colors will pull it all together.

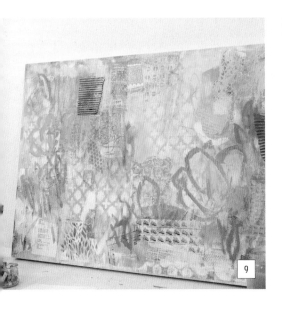

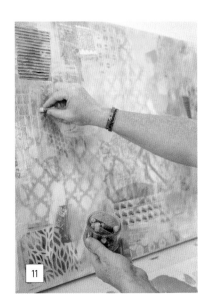

9 | To contrast the lush mixed media layers, create the impression of a botanical element. Use a bold acrylic paint color thinned down to a half-and-half consistency and create lines and shapes with a paintbrush (I used pinkish-red). These should be simple, not detailed, since this is another element that will tie the piece together. Instead of painting botanicals, consider adding symbols, a face, or a still life plant, like the one created in Lesson 1 (see page 50).

10 | Examine the value range. At this stage, the colors are high-key, but there still should be contrast to create interest. Use gray paint and a water-soluble graphite stick to loosely mark in more botanical elements that feel like leaves or vines or other elements that fit the overall theme of your piece.

11 | Create a few oil pastel marks as a finishing touch, and you can call this one complete and an absolute blast to paint!

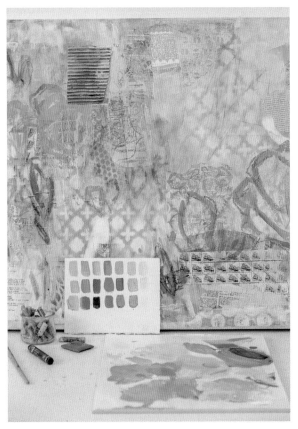

The dominant color palette choice is in the warm range of yellows, oranges, and corals. When we add in a little pop of teal, it stands out among the rest.

Guest Artist: MELISSA DOTY

"December Flowers"
10" × 10" (25 × 25 cm),
Acryla gouache on
watercolor paper
Website:
melissadoty.com
Instagram:
@melissadoty.art

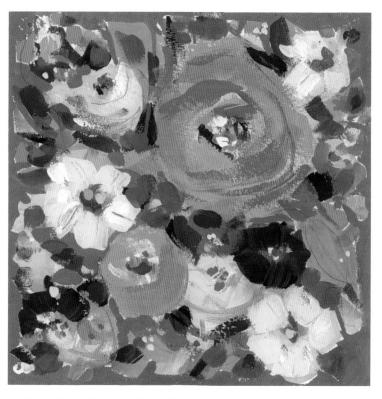

I rarely plan my colors for my artwork, and my grasp of the color wheel is rudimentary. Instead, I work intuitively and choose colors by feel. I typically start with my most saturated color; in the case of this piece, Opera Acryla gouache. This deep fluorescent pink does not feel girly or candy-coated. I painted my initial floral shapes: hot pink first, followed by orange-yellow, then dusty pink, and finally deep blue flowers.

When the white paper held several loose floral shapes in four colors, it was time for leaves. I started with a gray-green and gradually mixed in aqua for lighter, blue-green leaves.

I paused to consider the values and craved more lightness, so dusty pink flowers became ivory, and orange-yellow flowers became light yellow. I also needed more warmth, so I scattered vermilion and scarlet touches throughout.

I always choose my background color last and felt this steely gray-blue complemented the bright colors nicely. I added pops of color throughout the piece where I felt it was needed and stopped when my eyes were happy.

In preparing this write-up, I learned that this piece is full of tertiary colors. I'm gaining confidence in my intuition!

FINAL THOUGHTS

What do you need to do in order to be authentic in your practice and make more art?

If you feel compelled to make the art you've always known you were destined to make, then this is the path for you—whether you've always made time for art, never painted in your life, or put your dreams on hold for far too long. We are born creative with a desire to express ourselves, and making art is one of the most joyful ways we can do that. How can you find a balance between trusting yourself to make your artwork and pushing yourself out of your comfort zone?

Living a creative life doesn't happen overnight. You can't skip practicing, and you need to have patience to grow and become the artist you're meant to be. When you're determined to live a creative life, the passion for the work must come before the show, before sharing on social media, and before the fantasy of being an artist. Before anything. That's what we, as artists, must do—study and explore everything to do with making art and discover what lights us up when we make art for ourselves first.

You must make your art in order to know how to make your art.

This is what being a limitless creative means. It's not just about understanding color. It's about transforming where you were and becoming something new that's more powerful and exciting. It's about taking every part of your soul and putting it in your artwork and being willing to take risks. My hope is that this book leads you in that direction.

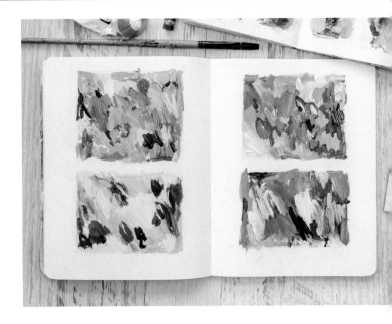

"Don't think about making art, just get it done. Let everyone else decide if it's good or bad, whether they love it or hate it. While they are deciding, make even more art."

—ANDY WARHOL

ACKNOWLEDGMENTS

My greatest gratitude goes to my husband. Without his stubborn, dedicated love to us as a couple, our family, and my happiness, I would have never taken the risks and overcome the challenges to becoming the artist and entrepreneur I am today. Thank you for always challenging me to be better, even when I want to resist the change. We did this together.

Thank you so much to my editor, Jeannine Stein. Wow, I can't believe how lucky I am to have you see the potential in my voice as an artist and give me the opportunity of a lifetime. Your guidance and support along the way made it possible, even though I had absolutely no idea what effort it would take when we began. This was the best possible pandemic project to undertake. Thank you for making it happen.

I could not have undertaken this massive project without my dear friend and photographer Becca Bastian Lee. More important than the stunning photographs that make this book what it is as much as the artwork itself, your encouragement when I was scared to take on this project (every single time we started a session) was priceless. When I said I couldn't, you just kept photographing until I did.

Also, I need to thank all my students for teaching me to be a better guide. When I began this journey teaching, I had no idea how much mutual trust would need to be built in order for me to succeed and for you to excel. It has been the biggest reward for me to see artists find their calling in creative expression.

There's no doubt that my dad inspired me to be an artist. Thank you for paving a path to show me that it's not only possible to be successful as an artist but it's even more important to embody the artist's life. Ever in the moment, reinventing the meaning of life with each new morning.

I am truly grateful to my mom for being my number one fan. From the time I was a little girl, full of spit and fire. It's only in looking back and reading every note I've saved that I can see that you have loved me wholly for who I am and been proud every step of the way. Thank you for always believing in me, Mom.

And thank you big heaps and kisses to my three boys. You are my greatest creations, always.

ABOUT THE AUTHOR

Kellee Wynne Conrad is a fourth-generation artist who grew up with art as part of her daily life. She worked for many years in the design industry creating trade products, running workshops, and having her work published. One day, however, she had the overwhelming desire to return to her roots in fine art and painting and went full speed ahead with her art career. Kellee has been represented by national retailers, was selected for an international exhibit in New York City, won signature membership with the International Society of Acrylic Painters, and has curated and juried exhibits for galleries and organizations in Maryland.

Her experience in bringing in new artists to galleries and running programs led her to build a business teaching global workshops and online art programs that use color as a foundation for learning mixed media art techniques. Kellee's Virtual Art Summit features top guest artists, and she coaches emerging artists to build a career with their art. Kellee studied art and art history at Monterey Peninsula College and the University of Maryland. She lives near Baltimore, Maryland.

INDEX